This Strange Idea of the Beautiful

T0079857

THE
SEAGULL
LIBRARY OF
FRENCH
LITERATURE

This Strange Idea
of the Beautiful

FRANÇOIS JULLIEN

TRANSLATED BY
MICHAEL RICHARDSON
AND KRZYSZTOF FIJALKOWSKI

Seagull
BOOKS

LONDON NEW YORK CALCUTTA

This work is published with the support of
Institut français en Inde – Embassy of France in India

Seagull Books, 2022

Originally published as François Jullien, *Cette étrange idée du beau*
© Grasset and Fasquelle, 2010

First published in English translation by Seagull Books, 2016

English translation © Michael Richardson
and Krzysztof Fijalkowski, 2016

ISBN 978 1 8030 9 057 3

Typeset and designed by Seagull Books, Calcutta, India
Printed and bound by WordsWorth India, New Delhi, India

To Liliana Albertazzi,
guardian of the avant-gardes

Contents

This work revealed a particular problem concerning the translation of the word 'sensible' which has a much wider range of associations in French than any comparable word in English and which plays a very important part in the text. Depending on the context, this word might be translated as 'perceptible', in the sense of being observable or tangible, or 'sensual', in the sense of what is experienced through the senses. Often, neither of these words is entirely appropriate since these meanings overlap. Except on a few occasions when we felt that 'world of the senses' or 'perceptible' were more appropriate to the context, we have therefore retained the word 'sensible', and the reader should be aware that whenever this word is used it relates to what is perceived or experienced through the senses.

The translators would like to thank Liliana Albertazzi and François Jullien for their advice on this translation.

Nothing is more suspect than the complacency with which the notion of the beautiful has been treated.

The chitter-chatter it favours troubles me because it closes off all investigation from the outset. Or if it doesn't, such investigation bears only on the everlasting problem of how the beautiful is to be defined without a prelimi-nary question being asked: Is it apposite to isolate the valorization of the perceived object under this word 'beautiful' which has gained a hegemonic status and even been raised to an absolute value? Was it not already too hasty to pose such an object (of the beautiful)? And did it not respond first to the needs of our metaphysics? But the beautiful has no less been enthroned in European culture without there being any investigation into the prejudices which have sustained it. Modernity has rebelled against

it without giving very much illumination about these prejudices.

The 'beautiful' is not self-evident. But how should it be questioned from a distance in order to shake so much conformism?

At the time of our classical reason, a dialogue between a Christian philosopher and his Chinese alter ego was envisaged without difficulty. Perhaps naively, for in what language could they speak which would not imme-diately cause the exchange to fall into the terrain of one or the other? Language was then thought to be transparent and neutral without it being suspected that we begin to think within its folds.

It is consequently necessary for us to intervene in order to arrange the conditions of a meeting between them and, rather than claim to deconstruct the notion head on, to go around it, to assail it through successive and newly linked developments, in a way that progressively, through the open divergence [écart], allows the basis of what we have not thought to appear.

To pass through China is not therefore to satisfy some itch for exoticism but, gaining from a wider view, to envisage the question from a more radical perspective. Or, more precisely, to bring forth a question in the very place within which it has not been discerned. The 'beautiful'

will then begin to emerge from its banality and even reveal a fascinating strangeness.

There is another dialogue I would have liked to develop here, less with China than with contemporary art. Does not everything in these pages call for it? In any event, the first elements of it are given, which are set as toothing stones. Because it is the artists, not the philosophers, who are the first adventurers, or, let's say, the pioneers of thought. Philosophy, as we know, is always a late riser.

I

BEAUTIFUL, THE BEAUTIFUL

Let us therefore begin from closer up, at the level of language, the resources of language that predispose thought. What happens when one goes from one to the other, from the adjective to the substantive, from 'beautiful' to 'the beautiful'? 'Beautiful' (as an adjective) is a broad spectrum. It obliges our development between these two possibilities: on the one hand, when it is limited, it expresses what is acknowledged as pleasant to the hearing or sight and therefore gives a feeling of perceptive pleasure; on the other, when it is without borders or order, a very much more general, non-extended, feeling of admiration or satisfaction is experienced—what is suitable, accomplished and successful. A 'beautiful woman,' says language but we can also say 'a beautiful goal', 'beautifully done', 'small is

beautiful'... *Bella cosa far niente.*[1] A goal or smallness are not 'beautiful'. When we pass to the substantive, on the other hand, this sense of the beautiful is isolated and becomes exclusive—the beautiful (beauty) is *the characteristic* of what is beautiful. From something diffuse in the understanding, simply because of the definite article, a meaning is extended and folded over itself that will be called 'aesthetic'. This is the beauty of a face, of a landscape or of a painting.

This is already true in Greek. So what will the consequence be? Homer spoke of 'the beauty of the body' (*kalos to sôma*). But we also read of a 'beautiful port' (*kalos limen*) for a well-situated port, or a 'beautiful wind' (*kalos anemos*) for a favourable wind. Ulysses wanders for a long time in quest of both in order to return. Here, 'beautiful' expresses that part of the world which serves as a resource and is offered to usage, which suits the situation and of which good use can be made, without for all that either sense, hearing or sight detaching it from the functionality of things as a proper and disinterested end. Without them being elevated into a music, such as the wind in the sails, or into a landscape—Nausicaa on the beach or the song of the sirens. On the other hand, the 'beautiful' (*to kalon*) exclusively designates what, extricated from usage and breaking these dependencies, is

held to be a specific quality—whether it is a question of moral or physical beauty. As is only right, the substantive substantializes (essentializes). In the semantic extent of everything that is appropriated, it sorts out and retains only what would be a pure and determined pleasure. The Beautiful is already erected as a proper aspiration and human vocation—we are now embarked upon it. . . .

What happens in other languages? Is such a semantic selection known that morphology is sufficient to operate? Let's consider the Chinese. What we today translate from the Chinese as 'beautiful' (*mei,* 美) oscillates between the two. On the one hand, there is an open meaning, that of the certifiable excellence and satisfaction in any experience—the plenitude of a capacity is 'beautiful'. Or, a neighbourhood in which a sentiment of humanity reigns is 'beautiful' (Confucius, *Analects*: 4.1). On the other hand, Confucius declares the music of Wu and Shao 'completely beautiful', the one being 'completely good' and the other not; or he speaks of an eye in which the white and the black are clearly distinct and contrasted as 'beautiful'. But Chinese does not morphologically distinguish between adjective and substantive—it does not say the 'beautiful' (or beauty), the beautiful as a notion and beauty as a quality. It does not isolate

the beautiful as a purely aesthetic sense which thought can then hypostasize. It was only by Western import, at the end of the nineteenth century (in China as in Japan) that 'aesthetic' would be translated ('callistic', they would also say in Europe in the eighteenth century) as 'study of the beautiful' (*mei-xue* in Chinese; *bi-gaku* in Japanese).

What results from this that is, already, decisive?

II

THE BEAUTIFUL:
EXERCISES IN PHILOSOPHY

What does Plato ultimately do as he builds up philosophy if not precisely to exploit this resource procured by the Greek language? Isn't it to learn how to pass from a beautiful thing to what constitutes the beautiful? This is even the point of entry into philosophy, and, in his dialogue on beauty (*Greater Hippias*), this difference is what the interlocutor of Socrates is slow to perceive and has difficulty surmounting. A beginner's exercises in philosophy: I am not asking you what 'is beautiful' but *what is* 'the beautiful' (*ti esti to kalon*). To learn to pass from the adjective to the substantive, in other words, from the description to the essence, from the concrete to the abstract, from circumstances to generalities—no longer to designate

but to define. We believed in a simple clarification, but the step crossed here is decisive, or, rather, everything follows from it. On it one will no longer be able to return, any turning back will be impossible—if things are judged beautiful, it is because *there exists* 'the beautiful' which renders them beautiful. In 'the beautiful' as substantive, what is beautiful is no longer seen as related to anything other but is withdrawn into what becomes its substance. It puts an end to its infinite dispersion into things in order to affirm itself as subject. The beautiful is thus not a 'beautiful virgin' (a beautiful mare, a beautiful lyre, a beautiful pot ...) but is 'in-itself' (*auto*), adding to all these various things. From what 'is beautiful' to 'the beautiful'— (European) philosophy was born from this added article and is promoted in this displacement.

A great shake-up is instituted, detaching the beautiful from what is beautiful. From now on, thought will cease to travel from one occurrence to another, like the honey bee, at the level of things, spelling out the world wherever its discovery is carried and being satisfied with this inventory—let us bid goodbye to everything anecdotal. From now on, it will construct itself in its own terms, above all by definition—as was settled by Plato for ever: working to render its unitary grip to emerge from this disheartening scattering of

cases and granting the sovereign overhang of the concept. Well, this is it, so it is done: the naivety of all realism—phenomenalism—pointing a finger at what it has before its eyes is surpassed. And Socrates jests: To let this idea of the Beautiful be assimilated to some ordinary material, even because it is found to be the same in so many various objects, would that not be altogether too ludicrous? Unable to be a thing, gold or marble, the beautiful will consequently become a notion. To consider that the marble rather than the ivory of the statue of Athena is beautiful 'because it is employed appropriately', is to seek the beautiful not in a too-openly-limited given but as a principle. It will easily pass through this teeming of the diverse. Would not 'appropriateness' (*to prepon*) here become the definition of the beautiful?

The first disappointment of the dawning and triumphant philosophy: just as thought comes unstuck when one goes from one thing to another in order to identify the beautiful by assimilation, here it gets lost anew as it forces us to wander from principle to principle. In the same way, are we not condemned to a reduction, no matter how we relate to the beautiful—which means that the beautiful still escapes? In pursuing that of which the quest of the beautiful is the exercise (still in the *Greater Hippias*), would a wooden

spoon be more beautiful than a golden spoon because it is more 'appropriate' to use? On the other hand, who assures us that what we take to be 'appropriate' is not simply apparent? Let us then rectify appropriateness by means of the 'useful' (*chresimon*), thereby giving its finality a more effective charge. But would the useful then not risk diverging from the good in aiming towards selfish ends? Let us then rectify the useful by means of the 'advantageous' (*ophelimon*). But the advantageous, in its turn, if it produces a benefit, would again be separated from the good, and so on.

If it is worth taking the trouble to keep going over these dialectical exercises in which Plato devoted himself to 'the beautiful', it is because they enable us to assess the difficulties upon which we find ourselves definitively embarked once we have raised the question of 'the beautiful'. Even the path of abstraction, defining the beautiful by a notion, which announced itself as the royal path, would perhaps no longer—at least not immediately—be the opening one might hope. Then why delay returning to what common meaning tells us and on which, at first sight, language bases its meaning: That the beautiful is 'the pleasure procured by hearing and sight', as Socrates, having won the argument, advances *in fine*? But could one still speak of moral beauty if the beautiful was limited

in this way to the perceptive? And, above all, why reserve the delight of perception to two of our senses (hearing and seeing) to the detriment of the others? Not being the province of a single sense, yet not belonging to all five, the beautiful creates the question of how it can at once arise from these two senses and from each of them separately indiscernible. Once again, the nature of what is in common escapes. Because to define, in the final analysis, the pleasure of hearing and seeing by the sole fact that it serves the most 'innocent' (*asines*) and the best, to separate the others from it, is just the first, stammering step in distinguishing the beautiful from the agreeable, and in emphasizing its character that would be described, but much later, as 'disinterested'. The enquiry conducted to this end has, in truth, only just started.

III

IN THE RUT
OF AN IMPOSSIBLE DEFINITION

.

However, all that Plato did, in once and for all marking out what would become, in its wake, the 'question of the beautiful' was to prevent us from being drawn from one side to the other in this investigation, even if this was to recognize that it cannot definitively be brought to an end. In the *Greater Hippias*, this question founded a lineage, one from which there would thereafter be no exit. Could it be abandoned? Could we be freed from it one day? Is there anywhere its looming shadow has not penetrated? The responses might vary indefinitely, but the question remains. This *conceptual effect* remains there; what remains, drawn out from language, is the beautiful. If we are unable to define what the beautiful is,

we do at least recognize that it 'exists', we 'believe' (*nomi-zein*) in its existence. So, if I again go over these philosophical exercises for beginners, it is because it is time to measure from the outside the extent to which they have formed us.

Indeed, is it a trivial point to note that when he wants to teach us to rise to the concept, Socrates (in Plato) always begins with the beautiful (which comes before the Great, the Good or the Just)? 'Beneath' the diversity of the appearance of things, what he is led to 'pose' is the beautiful—more precisely: to 'suppose' (*hupotithesthai* is the verb used, that of the 'hypothesis'; *Phaedrus*: 100). The Good can be raised as the keystone and supreme end, but it is *with the beautiful* that the education of the philosopher must begin— to teach him to pass from the plural to the singular, from the 'beautiful voices' and 'beautiful colours' to the unitary of the beautiful in itself (at the heart of *The Republic*: 476b–d714). More than this, it is from the beautiful—in the passage from the adjective to the substantive (to the neutral)—that asceticism first appeared and that we were set on the path towards the ideal. As long as we recognize only beautiful things, but not the existence of the beautiful as such, we live as 'in a dream'. In detaching the beautiful from it, we enter into true life and awaken to the 'idea'.

Inevitably, then, we must retrace the steps he took in conjunction with our own. We must set off again from this precise place, from this first text (the *Greater Hippias*) which has since been taken as the birth certificate of the question—in spite of all of the aporias following from it, it definitively established that there is 'something' (*ti*) which might be 'the beautiful', isolatable-identifiable at the same time, at least in principle, and which can be made the object of a discourse. 'On the subject of' which (*peri*) one might be able to speak (*Peri toû kaloû* is the given title), which assumes both distance and mastery in order to be grasped—even if it is necessary for this discussion, being unable to come to an end, to begin again indefinitely. *De pulchro*, the Latins say in unison (although they can only use it in the neutral, without the article). Because even if one no longer turns the beautiful into an idea with a metaphysical status, this much can be counted upon, borne along by the language and which Plato had the genius to make clear, hiding an enormous bias—that there is a 'this by which' what is beautiful is beautiful, in other words, that it is an essence of the beautiful, offered as such to the *logos*, even if our efforts to attain it remain vain. That this could be 'assumed', as Plato said, was from that moment enough. Admittedly, Aristotle did not

believe in ideas separated from sensible experience, but he no less considered it to be proven and even above suspicion (in other words, so that one does not even think of questioning its validity) that there is some literal being or 'quiddity' of the beautiful with the same capacity as the good, in other words, in the first rank of essences, in-itself-as-for-itself (*kath'hauto*) which would be affirmed only of itself, serving as a reason and principle at the same time and as such automatically delivered to knowledge (*Meta-physics*: Zeta 6).

Because one would then, like the Stoics, have redeployed its notion in vain; one would have distin-guished between its different fates in vain: between the cosmic beautiful made of form, grandeur, order, variety or colour, as one reads in the celebration of it in Cicero (*De natura deorum*); and, on the other hand, the beauty of the human body, of which the just pro-portion or 'symmetry' is placed in evidence—it no less remains that henceforth the question of the beautiful, like the Sphinx, imperturbably awaits its response. And that the latter bears in it the imprint of the whole system. Thus, among the Stoics, in conceiving the beautiful as a relation adapted from the parts among themselves, in this way is reproduced the mas-ter idea of the fragmentation of the Whole in each of

the parts of the world. Plotinus logically opposes this thus: In these conditions, could the One, the simple, the non-composed, be beautiful? Or, rather, tell me what your definition of the beautiful is, and I will tell you what your philosophy is. Crossing these gaps follow the most diverse syncretisms which commentators will never manage to unravel. In always starting off from Plato (the *Greater Hippias*), the list of definitions is extended. Again, in the midst of the eighteenth century, and in opening his *Treatise on Beauty*, Diderot in his turn was not afraid to review: the beautiful as internal meaning (the English), or as uniformity crossed with variety, or as a maximum escaping all the finesse of geometry, or as adaptation to an end, or as . . . Diderot adds his response in claiming, as always, to include them all: Under one angle or another, is the beautiful not necessarily (essentially) 'relations'? (1951)

Consequently, let's ask ourselves: In the wake of the question of the beautiful, and whatever passion it puts into it, has Europe advanced? Art has mutated infinitely; its revolutions continue. But the beautiful? Can 'the beautiful' be inventive? Unity–form–colour–relations–parts/whole–conformity–maximum–finality, and so on: one or another of these parameters could be moved, with emphasis brought to bear on one or

the other but without for all that coming out of this domain, such as Plato had started to measure, that is circumscribed and definitive. Diderot said it again right at the start ('Everyone reasons from the beautiful') but if we ask what is his exact definition, or its true idea, 'some admit their ignorance; others throw themselves into scepticism' (ibid.: 1075). 'Beauty' is really (like 'time'), in this respect, the type of question which the West is mad about, a question which from that point is essential to thought, carried along by language, judged 'necessary' but with no end result; and the enigma once again comes up against the rut. This raises the suspicion (or would it already be regret at such a beginning?): Instead of allowing ourselves to be dragged into this Platonic trap, would it not rather have been necessary, without posing the 'beautiful' but in following Hippias the sophist, to have been content with naming everything, by pointing the finger, that falls under one or the other meaning, whether it is heard or seen, and from which the exclamation of pleasure arises, as 'beautiful'? Or is it necessary to *think* the 'beautiful'?

For did Hegel, who claimed, once again, to have the last word, say anything more in this regard than others? On this path (that of the definition of the beautiful), is progress possible? I would define the

beautiful by what is acknowledged by itself (*quod per se ipsum deceret*), as the young St Augustine had already put forward according to what he relates in his *De Pulchro* which is today lost: through difference with what is 'adapted' (*aptum*) which is appropriate by its adjustment to something other, the beautiful (*pulchrum*) is the conformity of an object with what it should be, or, more accurately, to what it is acknowledged to be, and which forms its perfection (1998: Book IV). But is it not, according to this same demand of a redoubled conformity, in two stages, in other words, of an effective conformity, at the heart of the sensible, to what is in itself in conformity with the self, that is, in its principle or idea, that Hegel equally defined the beautiful against those who, in the midst of romanticism, celebrated its indefinability? Is it possible to emerge from these terms: the beautiful is the phenomenal manifestation adequate to the concept, that is, realizing in exteriority and objectivity what conforms to the internal content, itself in conformity with itself (*Angemessenheit zu dem sich selbst gemässen*—Hegel 1986: 205)? The structure in which the beautiful holds us is that which goes from the conformity of the sensible to the interior conformity which is appropriate to the 'idea'; and Plato, in leading us from the particular of beautiful things to

the universality of the beautiful, and then starting to define the beautiful by its appropriateness, effectively opened the path. A furrow was marked out (was it a vein?) which has since then only been extended.

Nevertheless, what is there within this Platonic abstraction, Hegel asks, that no longer suits our modern needs, which would be lost, and which Hegel himself names with the term with which we in Europe have long since understood to designate in the most universal way, in a gesture of adjustment, what still risks eluding this Platonic 'flight' of thought—the 'concrete'? (ibid.: 35–40) Could taking a detour through China be another way of recovering this? Not so much in order to renounce the beautiful than, finally, to make it a 'full' concept—*voller Begriff*. Because if to define the beautiful, which has become an obsession since Plato, ultimately means to lose one's way, it is perhaps because we have not known how to locate the theoretical biases from which such an 'idea' was born. What singular resources has it exploited? Who tells us that the question of the beautiful is essential for us and is, as such, inescapable? Who tells us that it is everywhere? If we want to re-establish the fertility of thinking about it, it will be more profitable, I think, to begin by restoring its strangeness.

STATEMENT:
CHINA HAS NOT BEEN AWARE OF THE
MONOPOLIZATION OF THE BEAUTIFUL

For this task, let us start out again from this sense of elsewhere and this statement. Not only does the Chinese language not operate this easy slippage from what is 'beautiful' to 'the beautiful' through the simple addition of an article, so turning the beautiful towards the universal of the concept (and if Chinese thinkers have also been able to elaborate markers of abstraction, they have not found the same comfort in the language, at the level of its morphology). Equally or, rather, regressively, and no doubt one does not go without the other, in order to express what we in the West call 'beautiful', the Chinese language has taken care not to privilege a unique semantic element. As a

result, has it in fact expressed what is 'beautiful' as European languages have been able to do by giving this term a hegemonic meaning? What European languages designate through a monopolizing, not to say exclusive, term (*schön* or *kalos*), the Chinese have allowed for a very much greater diversity of usages and formulae which are dispersed across a whole web of correlations. The thread of the language cast upon 'what is pleasant to hearing and sight', to return to the formula at the root of the *Greater Hippias*, is so much more interwoven; and there are numerous terms in this respect which, discreetly differentiated, are equal in the way they are used, or they intersect so well that one can hardly distinguish between them. Or they vary according to the idiolect of their author. *Mei*, which we translate today as beautiful, and which has henceforth served as a patented equivalent, is not dominant, at least not in its tradition.

Thus, when all is said and done, could Chinese (or Japanese) histories of 'aesthetics', copied as they are from the Western model, ever find anything within their own culture which corresponds to this 'necessary' question of the beautiful in the way that the Greeks once presented it?[2] They can show at leisure how such and such school of thought, dating from Antiquity, has favoured an extreme sensibility

which today we commonly call the 'beautiful', taken from Europe through theoretical globalization, but they would no less be at a loss to say what term, in their language, would synthesize such a realization and clarify it. 'If we turn to China,' says François Cheng, 'we see that the founders of the two major currents of thought have advanced the virtues of beauty' (2006: 88). I am willing to grant this—but what is the notion which, *in Chinese* before the encounter with the West, expresses 'beauty' in this unitary and general way, prescribing it as a common notion?

For Confucians, appropriately, it is then simply a question of ritual performance or musical emotion, each of which balances the other; or of 'spiritual rambling' and internal availability, freed from correctness and favourable to the release of an authentic talent, like that of the painter at the Song court (in the *Chuang tzu*). So I distrust this quid pro quo of our time which, far from favouring the so-called dialogue of cultures, tends to undermine it and even, I believe, to distance us from it for ever. Those who—in China and Japan—immediately and without further elaboration resort to the (European) notion of 'beautiful' in order to deal with their tradition are, inadvertently, in thrall to an illusion, on the cultural level, that is

analogous to an anachronism in the historical order. It is as though because there is, in these civilizations or others, a cultural refinement manifested at the highest level reflecting the 'pleasure 'of hearing and seeing', one must have a concept of the beautiful to crown it. Suppose, then, that the perspective was reversed? Perhaps on the contrary it is this crown of the beautiful which would then awkwardly conceal such a play of nuances and correspondences to the point of erasing them; as a result, alone bringing into prominence the question (of the 'beautiful'), establishing it as inescapable at the same time as it is unanswerable, and projecting its shadow over thought.

The remark comes to me notably from the strange regret I hear even among the most sinophile of my friends. All those people who have had in hand that most ancient of Chinese books, the *Book of Changes* (*Yi-jing* or *I ching*), whose text developed in successive strata through the course of Antiquity, never fail to notice that none of the sixty-four hexagrams of the book, addressing the most diverse situations, explicitly deals with beauty, and they are often disappointed by this. Only hexagram 22 (*Bi*), which is far from being one of the more significant, speaks of adornment or embellishment: the ideogram which designates it represents in its lower part the cowrie

(a shell which once served as currency and signifies everything which is costly), and in its upper part the treble sign for vegetation, evoking the budding taking place outside and the spring blossoming. We notice that the whole hexagram expresses a movement of exteriority joined to the evocation of what is precious, but without developing the idea of a pure perceptive (visual, auditive) pleasure which would be considered fully.

Let us consider how this figure of embellishment appears in the sequence of the book: it occurs after the moment when it is judged necessary to have recourse to rigorous measures in order to re-establish harmony (hexagram 21, *She he*, 'bite' forcefully to eliminate what stands in the way, and 'reunite' and so 'succeed'). And it comes before the moment when the factors of weakness gather to eliminate what is strong (hexagram 23, *Po*, 'erosion' to the point of a stripping bare). The perspective in play becomes better evident— cultural representations should always be considered from the perspective which has carried them along in order to avoid ethnocentrism, or what I would here call 'ethnomonism', the 'monism' (of the Beautiful) being that of the West: the embellishment is only one *moment*, one in which, in the hexagram, the supple factor (*yin* - -) is mingled with the solid one (*yang* —) so

as to prevent it from hardening (the lower trigram ☷);
then the solid factor (*yang*) comes in its turn to stand
in the way of the supple factor to prevent it from
weakening and becoming excessive (the upper tri-
gram ☶). If there is an 'embellishment', it comes from
the fact that the two opposed factors cross each other
in a single motif (*wen*, which commonly means con-
figuration, text, order and civilization, designates pri-
marily such a crossing of lines); and that the interior
manifests itself externally, emerging first of all from
the extremities (in the first lines of the figure: the
'foot', the 'beard') to the point of concealing every-
thing with a tone (like 'white' dominating the shape).

What then is the lesson to be drawn from this
'embellishment'? It is that of a delicate alignment by
means of diffuse 'impregnation' (line 3) and 'blurring'
(line 5), the whole avoiding break-up. Consequently,
nothing is prominent that might become detached
and catch the attention and then capture and seduce
the gaze, or charm it, as when we say that 'it is beau-
tiful'. And this alignment is temporary—as it ordi-
narily is in China, the point of view involved is that of
a continuous process regulating the factors in play and
driving all outcomes, in the world as in conduct.
Without therefore having isolated within it and seeing
itself as separate and complete, extracted from the

sensible world and instituting itself as ideal norm, some substantial 'what'—a subject cut from all process—that would be 'assumed' under this diversity and be called the 'beautiful'.

V

WHAT DO WE LOSE OWING TO THE BEAUTIFUL?

But, someone will say, does art not itself necessarily include the promotion and clarification of the beautiful? We now know how China is provided with a rich artistic, notably, pictorial tradition, and within it how much the *Arts of Painting* has multiplied under the brush of people of culture. This raises a question: For all that, has this led to consideration of the 'beautiful'? Reading once more Mi Fu's magnificent *Hua Shi* (*Notebooks of a Connoisseur* [2000], in the eleventh century, at the time of the full flourishing of Chinese painting, of which Mi Fu was one of the greatest exponents), I find within it a complete range of formulations which translation uniformly simply reduces (how could it do otherwise?) to the imperialist term of 'the beautiful'.[3] How did this man of letters express

his admiration for the pictures he collected? He simply says that such painting is 'superior' (*wèi shang*), 'vibrant' (*huo*), 'excellent' (*jing-hao*), or 'successful' (*jia*, the most common term); it is 'accomplished' as if by a 'natural effect' (*ru tian cheng*), or possesses an 'inexhaustible charm' (*wú qiong zhi qu*). His formulation oscillates from 'seductive' (*yan*), which is what does not always avoid vulgarity, to the 'dimension of mind' attained by art that reaches its peak (*ru shen*). Or he has recourse to some associations, the two terms of which accord through a delicate equilibrium as previously, on the figure of 'Embellishment', the 'supple' and 'solid', *yin* and *yang* factors: flourishing/rich (*xiu-run*), or limpid/pretty (*qing-li*), or secret/elegant (*you-ya*) and so on. In short, this semantic field remains diverse and no term is predominant within it.

But let us move on some seven centuries later, at the end of this great tradition, and repeat the examination (in the company of Fang Xun in the eighteenth century, before the European influence started to penetrate China). We will still not find the Chinese term (*mei*) which is today used to translate the word 'beautiful'. But there is often a question of 'beautiful—success' (*jia*), or 'seductive' as opposed to 'ugly' (*yan/chou*), sometimes associated with 'pretty' (*li*) and sometimes distinguished from it. To speak of the

supreme quality of painting, the emphasis is sometimes placed on the spontaneity of its achievement (*miao*), sometimes on the spiritual dimension which emanates from it (*shen*), sometimes on the two in combination (*shen-miao*). It is certainly not this variety of formulae which forms the divergence with Europe but that, appreciation remaining plural, no term here is hegemonic, and we can well see that it is not a simple question of words—the descriptive field remains effectively covered in various magnetizations; it does not allow itself to be ordered by some unique perspective.

I spoke earlier about the statement because China in fact places us before this divergence which gets us thinking—the ramifications we perceive through this whole descriptive web (its tensions as much as its correlations) organize sufficient resonance as well as coherence between them so that one would no longer have 'to suppose' (in Plato's sense), in other words, to place beneath them some 'essence' of the beautiful in order to ground them in 'Being'. At least, provided we read a little closer and in Chinese. To evaluate them, which I have taken my time, I admit, by means of rereadings, is not to give into a 'narcissism of small differences', as Freud rightly ridiculed; nor is it to take pleasure in an alterity of principle, as some considered

it to be clever to reproach me, but to engage a choice that ordinarily has barely been clarified and yet is essential. Because the two things are part of a whole: either, at least implicitly, one projects one's own expectation (the 'beautiful') and then allows these various terms to be reordered, as so many variants under this expected and logically implied beautiful (an assimilatory reading that is no longer disturbing and, where everything which might still exceed it, in relation to this implicit, is even agreeably tinted with an exotic charm); or one agrees to give all of these glimpsed *divergences*, so easily lost once they are translated, their chance (this is the choice I follow here) and therefore to contemplate, as an adventurous explorer of what is human, wherever they may lead.

They lead us, for example, right to the point of reconsidering that domain in which the beautiful nevertheless most clearly could manifest its prerogative: Since the time of Homer, has not the beautiful been used, above all, about the human body? Now, in China, people could also speak on occasion of 'beautiful characters' (*mei ren*), even if it is not so much the form or the appearance of the body that is taken into account. From the Ming era, notably under the growing influence of the new genres of theatre and the novel, more popular and calling for illustration, the

beauties of the gynaeceum could become a subject of painting. And already, the painter Zhou Fang, a precursor of erotic painting, like everyone in his century, it is noted, 'considered beautiful' the plumpness of women (Yu Jianhua 1996: 492). In itself, the remark seems anecdotal. So much is true that the cultured tradition was ordinarily suspicious of all the prettiness which captivated the gaze of the crowd and diverted it from what should be the very principle of painting. What matters is in fact the atmosphere of internal nobility with which the character is imprinted and which the representation must convey: although the appearance of the women of the palace might be 'strict and severe', there would consistently be found in it a spirit of 'ancient purity', from which naturally follows a 'majestic, imposing and worthy appearance' (Guo Ruoxu 1964: 451)—a majestic and worthy 'beauty', the translators stress, both in English and in French, once again rendering the formulation in a too-uniform way (in the French translation by Esconde [1994: 81], or the English by Bush and Hsioyen Shih [1985: 106]). Moral or, rather, ritual connotation prevails here over a valorization *per se* of the beautiful. Thus the representation of 'pretty women' will only be an object of diversion for men of the world; it entertains them, we are told, but without

it allowing us to 'penetrate it further' (Mi Fu 1964: 147).

However, could we ever stress enough how much translators into European languages are drawn, in spite of themselves and in a monolithic way, into rendering as 'beautiful' what the Chinese have no less spoken about in various ways, and by using compound terms which both rival and counterbalance one another? While the beautiful in the West has been the channel, or the funnel, of our preferential perception, as well as of the valorization of its object, the Chinese every time withhold specific features which characterize (typologize) without for all that subsuming (Chinese reason would be, to use a Kantian word, less conceptualizing than 'schematizing'), which maintains in equilibrium the interaction at work (the two go as a pair) in the act, in step with the well-known *yin* and *yang* from which the engendering of the world follows, as the representation of 'Embellishment' has already shown, instead of allowing it be concealed and frozen under a unique label. What is it in China, therefore, that resists the reign of the beautiful? Not only does the Chinese formulation restore us to this side of the monopolizing effect of the concept, thus keeping us as close as possible to an originary perceptive but also it keeps us connected to

the dynamism which never ceases animating the world and deploying it. In his translation of Shitao, Pierre Ryckmans each time translates what the Chinese expresses, for example, from the first page, by a compound which it is true is very difficult to render notionally (abstractly) elevated (flourishing)—scattered over ('here and there', *ziu-cuo*) in a stereotypical way as 'the beauty of the landscape' (Shitao 1984: 9; see p. 33 for the translation of *jing-ying* 'fine (subtle)-flourishing [refined]'). I note that the translator into modern Chinese adds *mei*, 'beauty', as though it had now become a matter of a necessary support (Li Wancai 1996: 179). But at this point in the classic Chinese, the attraction exercised by landscape is expressed sufficiently well without the beautiful subsuming it; this tension between one and the other (between the 'prominent' and the 'scattered', between distinction and dispersion) is not concealed but allowed to live. In this state, what *arises* and catches the gaze is still grasped in its native, evolutive, *here and there*, and is not arranged in an orderly way.

This causes me to wonder: When I have climbed the hill and the landscape is revealed to me, causing me forthwith to fall into this unitary abstraction, if it leads me at the same time to lose my capacity of 'apprehension' (*shou*, 受, one of the key words of

the *Shitao*), what does it mean to say 'that's beautiful'?
Would not 'beautiful', by its qualitative covering over,
be too simple a designation, a label applied after the
event and become contemplative, already placing me
in secession from the 'here and there' arising, at once
dispersed, correlated and endlessly organizing, if
always in a inchoative way, from things and their plays
of polarity? Would not 'beautiful' already be too *loose*?
Too distanced and recomposed? Would it not already
set up an obstruction to my improvised discovery of
the world by brutally affixing itself onto it? Or, at
least, what does it *obliterate*? It gets in the way, not so
much in the singular, our traditional adversary in rela-
tion to the universality of the concept, as in the gen-
erating couplings which continue to place the world
harmoniously under tension and to promote it—and
in this our gaze itself is actively involved. Let usnot
forget that 'thing' in Chinese is expressed as 'east-
west' (*dong-xi*), already a correlation; or landscape,
'mountains-waters', (high and low, *shan-shui*), again
an interaction. So 'beautiful' has already caused us
to topple into what results from it, forgetful of its pro-
cess and disconnected from vital interactions, isolated
on its pedestal.

THE BEAUTIFUL:
LYNCHPIN OF METAPHYSICS

And so how has this pedestal on which beauty is raised—a pedestal which suddenly appears to us as strange, in truth, once we espy it from a distance—been erected? How did we finally come to the point of raising a statue to 'the beautiful' in Europe, as immobile-imperturbable as the Divinity? Baudelaire: 'I am beautiful, O mortals! Like a dream of stone' ('Beauty'). This statue of the Beautiful has since gone around the world, everywhere and very conveniently transported, like those of gods fixed in their palanquin. For if the beautiful is removed from the living, it is because it has effectively chosen to withdraw from the perishable and the contingent, from the individual, from the scattered, from the 'here and

there' and from the anecdotal—from all that would compromise it. It cuts the mooring ropes, on all sides, to what still attached it to becoming, made it depend on the order of processes and their polarities. Seceding from the world, it withdraws onto its essence, holds onto its secret. Baudelaire again: ' . . . I again sit enthroned in the sky like a misunderstood sphinx'. Some things would be beautiful only through participation but still too vaguely—hesitant, uncertain— for what has been glimpsed in this Elsewhere towards which the gaze henceforth remains turned. All by itself, the Beautiful has succeeded in raising this great dramatic scene characteristic of European pathos– distance–desire–suffering and insatiable search for 'docile lovers' coming to grief on her breast, 'by turns' ready to be sacrificed to it.

Not only does the beautiful abstract itself—going from what is 'beautiful' to 'the beautiful'; not only does it extract itself—going from the sensible to the idea, becoming the place of an asceticism which would cause us to forget the too easy and fragile charm of 'beautiful voices and beautiful colours', and from which we would finally gain access, from what was only dream, to 'awakened' life; but, what is more (in other words, in the case of itself), the Beautiful isolates itself, brings itself back home and purifies itself:

'I unite a heart of snow with the whiteness of swans . . . ' (Baudelaire). The beautiful heroically cut itself off from everything which mingled with the other, inscribed it in a relation and would maintain it in the network of tensions and interactions from which it has never occurred to China that one could definitively absent oneself. It is even in relation to the Beautiful, with a view precisely to speaking about this purification and elevation to the Beautiful, that Plato (following Anaxagoras, evoking the *nous* or 'mind'; see *Fragments*: Fragment 13) invented—a decisive moment in the history of Western thought—the phrase which will express the absolute for us: categorically breaking with what would particularize or localize it, or refer it, and raise it from any perspective, maintain it in belonging, taint it by experience and keep it in dependency. It is by way of the beautiful that for the first time what is excluded from every condition is expressed, promoting itself characteristically as *un*-conditioned and uncovering an extraordinary strength in this exclusivity. This has since then created an oppressive destiny.

A problem, indeed: Because how, as, the Greeks were well aware in thinking *logos*, can the withdrawal of all relation be expressed when 'to express' means to place in relation? In relation to the beautiful, Plato experimented for the first time with the power of a

negative theology which does not allow thought to fall back anywhere, each time liberating it from what would restrict its flight and thus keeping it safe from all alienation. A fascination of the 'pure', the non-indentured, the unrelativizable, of what resists all dividing up and coupling. Vertigo: On what wonderful beyond would the sentence be insufficient to open in cutting with an axe into the play of correlations— as so many compromises? What other possibility would it not effectively cause to arise, but by suggestion, from above the terrestrial horizon, as soon as this rejection is systematic in controlling completely every case, in crossing swords on all sides in order not to allow the particular to approach the Beautiful and contaminate 'It'. Plato indulged in this joy (through the voice of Diotima in *The Symposium*: e211–562) 'as the wondrous vision that is the very soul of the beauty he has toiled for [...] It is eternal, unproduced, indestructible; neither subject to increase nor decay: not, like other things, partly beautiful and partly deformed; not at one time beautiful and at another time not; not beautiful in relation to one thing and deformed in relation to another; not here beautiful and there deformed; not beautiful in the estimation of one person and deformed in that of another.' With possible determinations completely neutralized, what will finally be allowed to appear? A 'beauty'

disembodied from everything, reliant on nothing, not allowing itself to be reduced under any angle, which 'will appear not like a beautiful face, or beautiful hands ... nor like any discourse, nor any science. Nor does it subsist in any other that lives or is, either in earth, or in heaven, or in any other place.' Not having to relate to anything, this beautiful can only be self-referential—reflecting itself in the self, feeding on the self, 'it is eternally uniform and consistent, and monoeidic with itself,' says Plato, unable to emerge from such an enclosure and its redundancy, and, consequently, 'from a single essence' (*monoeides*).

Nevertheless, we know that this did not satisfy Plato. This hypostasis by absolutization of the beautiful itself is only one aspect. After having torn the beautiful from the individuality of a 'beautiful body', so as to transfer it progressively 'over everything', then to have transported the generality thus acquired, having loosened it from the sensible world, from 'beautiful actions as from beautiful sciences', we gain access to knowledge of the Beautiful in itself, forgetting all generation and process, yet this is still insufficient. Because where is the strength of this ascent to be found? How are we to connect ourselves with this place that is separated from essences, this *topos tôn eidôn* which constructs metaphysics in order to establish this world in

stability and truth? Only the beautiful can help in this regard; only the beautiful offers this recourse and this mediation. This is really why it bears within itself the fate of European thought which binds itself to it like a vine on a thyrse tree.

Indeed, we cannot enter into the thought of the beautiful without determining why (European) metaphysics has needed the beautiful as a tool indispensable to its construction, and in consequence, the exceptional role it makes it play? Of all ideas (of good, of justice, of wisdom . . .), the Beautiful again finds itself with an unrivalled privilege. This turning point can be verified in *Phaedrus* (250b–d): not only has the transcendence of the idea started to be conceived from that of the beautiful, but also it is the beautiful which, in an inverse sense (because, alone, its task is to 'glisten' and become manifestly essential under our eyes), brings us back to the nature of ideas at the very heart of the sensible world into which one day we had fallen—the eschatological fiction certainly being there only in order to deploy this separation of spheres more effectively. It alone can thus transform this nature of ideas into an *ideal* to which we can aspire. Or, again, it is really through the beautiful that we apply ourselves to the detachment of the senses as to the abstraction-absolutization of the idea, but it is

equally—inversely—in this emotional addition, this shock and trembling, that we suddenly experience, openly, face to face, at the sight of the beauty of the lover, that we find ourselves remembering the beauty glimpsed Over There. It alone can link the two. Because without the Beautiful, could we even dream about Heaven? How would we experience it even if only through nostalgia? While, says Socrates, other ideas possess no luminosity in the images of this world and leave such difficulty in perceiving some resemblance in them, beauty alone has this characteristic fate of being at once 'the most manifest' and 'the most desirable' (*ekphanestaton-erasmiôtaton*)—it alone is able to mobilize us.

Plato's coherence, therefore, lies in having considered both at the point of thinking conjointly this: without the beautiful, we would not even think about a world of ideas which could itself be an idea (pure, eternal, absolute . . .) if we were not radically separated from it; but because, while issuing from this place of ideas, the beautiful is alone inscribed at the heart of the sensible world, it beckons to and extends us towards this surpassing. In order to illuminate this mediation of the beautiful, let us even give these superlatives that propel us inside-out into the immediacy of the here and now and flesh and matter all of

their importance—the beautiful is the object of the most captivating desire, the *erôs* of the amorous urge; as it is, while belonging, as of right, to the invisible which results from what is most visible at the heart of visibility. Indeed, the Greek says precisely: the beautiful is what erupts at the heart of the visible and renders it so much more visible through this 'sudden appearance' (the sense of *ek* in *ekphanestaton*). It is, through what it suggests of an Elsewhere, what enhances the visible and carries it to its greatest intensity. Let us read what could develop so phenomenologically: the beautiful emphasizes the visible through its emergence as it leads it to an extreme through its excessiveness. In other words, that it distinguishes and promotes it solely because it does not reduce itself in it. Or, again: it carries the visible to visibility all the more effectively owing to calling for its renunciation.

From this contradiction revealed by the beautiful, Plato did nothing less than disentangle what the human condition might be—as the beautiful demonstrates to us, man is the being who bears within himself a sense of the Elsewhere' (which is what essentially explains 'thinking'), he participates at once in the Here and in the Over There. Through what the beautiful reveals to him about the Over There, he is unable to be content with the Here; from brushing

against an elsewhere, he is already thrilled. It is also within the beautiful that he therefore discovers what his vocation is—the beautiful is, in the full sense, an initiation (leading back to the Over There, where the language of the Mysteries is not simply decoration). With, on the other hand, this consequence from which comes the continual agitation running through the Here of life in such a way that it promotes our sense of existing (Plato opens up a mine leading to art and literature): I feel so much more present in the world when I leave it; in the same way, the beautiful captivates our gaze through what absence opens up within it.

VII

SEPARATION-MEDIATION:
ON WHAT THE BEAUTIFUL IS PERCHED

How many times have we gone through this? How many times have we returned to these *loci platonici* (from one age to another, from one rereading to another: Plotinus, Ficini and so on)? What have they definitively instituted from which thereafter the beautiful could not be detached? If I too linger over these all-too-well-known places of Platonic thought, too well assimilated still to be able to speak to us, it is because it is necessary for me to take the time to restore them to their strangeness. Indeed, to what extent have they been read, considering how much they have formed us? How far do we remain indentured to them, no matter what criticism is made of them? For they invented these two conjoined moments

(of *separation* and *mediation*) which would be the two major operations (one implying the other) of European thought. If the beautiful assumes a place of the first importance in this, it is no doubt due not so much to an interest in beauty as because it is the best peg, or, let us say, the only 'bolt' that European thought has been able to find able to hold together what philosophical dualism and, earlier, religious asceticism (Pythagoras before Plato) had begun by opposing: the visible and the intelligible (*oraton/ noeton*), and the empirical and the Idea. The 'beautiful' alone, belonging to both, penetrating most profoundly the heart of the sensible, brings to it the necessity of separation from it—the beautiful 'gleams', as Plato said, with the nostalgia which inhabits it, and it is really this theology of the in- and de-incarnation— the divine immersing itself in the flesh in order to withdraw from it, and taking pride in this retraction— which makes it the centre, or the pivot, of the way in which we in Europe have chosen to dramatize what will cease, simply, to be life and from that point on become 'existence'.

The proof *a contrario* is Aristotle, so little given to drama. If Aristotle recognized, as the Greek language calls it, an essence or 'quiddity' of the beautiful but did not develop it into a philosophical question,

it is precisely because, no longer separating ideas from the world of the senses, he also ceased to need such a mediation (the beautiful) to gain access to them. On the other hand, or, rather, by contrast, because the separation between the sub-lunar Here and the celestial Over There from that moment is for him henceforth so settled (between the corruptible and the incorruptible, the necessary and the contingent), or their heterogeneity is so radical (as between physical and theological), that no participation of one in the other can any longer be envisaged. What then would the value of the 'beautiful', or of what revelation could it be the object, if the divinity of the stars is from that time completely alien to our world? We are therefore not deceived by it and take it as understood—we will also better understand why other cultural traditions have been able *not to isolate the beautiful*: our interest in the beautiful does not initially depend upon the fact that it could serve as a concept for art or would simply manage to express the emotion experienced in the face of nature—Plato himself limited the experience of the beautiful to the turmoil of desire when we are faced with a lover; but we would need the 'beautiful', in the metaphysical instigation of the Ideal, as a *logical* tool.

Equally, no matter what reticence we feel, as in the school of Foucault, about putting forward the

word 'tradition', ordinarily such a lazy term, I cannot see how to avoid it here: so marked is the effect of a rut on this issue and it forecloses of itself any other possibility. Even in the critique introduced by Kant in respect of metaphysics, this mediating function of the beautiful re-emerges just as vigorously and necessarily: Kant also, really and logically, needed *to retrace this route through it*, from the moment that he maintains the condition of a dualism. As long as we continue to separate the two domains of the sensible and the supra-sensible (*sinnlich/übersinnlich*), in Kantian terms those of nature and freedom, the one subject to the legislation of understanding and the other to that of reason (the first employed for concepts, the other for ideas), must one not imperatively promote a term or median member (*Mittelglied*: that which serves the 'beautiful') to connect them? The 'beautiful' has the task of ensuring this assumed unity which, although 'unfathomable', guarantees the coherence of the whole, and transcendentally links the two (the finality of nature to that of freedom—see the introduction to the *Critique of Judgement* [1978]).

For if an 'incommensurable gulf' forevermore separates the supra-sensible from the sensible to the point that no path goes from one to the other, the feeling of pleasure produced by the beautiful would no less be intercalated from it, as Kant tells us, and in

an even more valuable way, between the two: between the power 'to know' (constituting the phenomenal object), and that of 'desiring' the good (discovering the wholeheartedness of the will); in the same way, the faculty of 'judging', as it bears on the beautiful, finds itself included between those of understanding and reason, linking the empirical (of pleasure) to the a priori (of judgement); or, again, beauty is introduced as a characteristically human standard between the 'agreeable', which is shared with animals, and the 'good', valid for all reasoning beings, including spirits. . . . We will never finish enumerating these mediations presupposed by the beautiful. There will therefore really be, according to Kant, only two parts to philosophy (the theoretical and the practical), but three *Critiques* are nevertheless necessary and in fact it is the third (of 'Judgement', and starting with the beautiful) which will ultimately be the centrepiece of the whole system, since it allows us to conceive of the celebrated 'pathway' or *Übergang* (otherwise recognized as impossible) between the two others. Who could then be sure that Kant had an interest in the beautiful for itself, or that he ever, in his whole life, actually looked at a painting?

If there is a divergence in this respect, between the Ancients and the Moderns, is it not rather based simply on the way in which the two separated 'spheres',

Gebiete (the sensible and the intelligible), are evaluated in relation to one another? Either one or the other loses value in relation to the other—it would become necessary to lift oneself up out of the mire of the sensible world to raise oneself to the level of the spirituality of the idea. Or the two are considered equally necessary to human development and a happy balance found between them. The mediating function of the beautiful will correlatively be found to be modified: either the beautiful, as *passage*, will only be the condition of a uniform progress, or it will be maintained in its function as an *interface* and be the golden mean in which the two oppositions become reconciled. But for the first option, that chosen by Plato and still more by Plotinus, we already see the paradoxical consequence—the more the beautiful is intensified, purified and disembodied, the more it is made to erase itself. Deploying its ontological scale from the beauty of the body to reason (*logos*), which is within nature and imitated by physical beauty, then from this natural beauty to that of the soul, and then from the beauty of the soul to that of the intelligence residing within the soul as in its material, such a beauty, becoming 'first', from elsewhere or from 'Over There' (*ekei*, see Plotinus, *Enneads*: V, 8, 3), ends up becoming confused with the Good; in so doing, it culminates in it and

abolishes itself. A confirmation once again of the fact that, in the construction of metaphysics, the beautiful is valued less for its own determination than—increasingly gaining in transparency—its ability to serve as a philosophical intervention.

The Greeks (Plato to Plotinus) looked at the 'beautiful' through the eyes of the lover looking at the beloved, a look that is fascinated and bedazzled. So they could only appeal to liberate themselves from this capture and tie—an anthropological experience which in the end is circumscribed and, owing to this fact, strange: this source of the beautiful was led by itself to dry up under the extension of the Good, leading to the renunciation of the body just as it illuminated the entire Being with its unique light. The Moderns, or, rather, the 'pre-moderns' (Schiller), once more took up the terms of this metaphysical dualism as though it was above all suspicion (such, in fact, is 'tradition') and according to these fixed antinomies: on the one hand, the 'sensible' (time, nature, exclusion, finitude . . .); and on the other, the formal (the absolute, reason, freedom, eternity . . .). But, choosing to take the better part of both, they then retrospectively projected harmonious equilibrium onto the Greeks: Was not the beautiful always enhanced by what one had exiled it from, what one had distanced oneself

from in sinking into the body, or, inversely, into the speculative? The ancient nostalgia for Heaven turns into that of a Golden Age and the Beautiful prevails, once again, over what it has lost. It remains the case that, from that moment, this beautiful could no longer abandon its sensible aspect in the name of asceticism, the logic (or, here, the rhetoric) then ceases to be escalation or graduation and becomes a balancing. The beautiful is the point of intersection in two senses: 'By means of beauty,' says Schiller, 'sensuous man is led to form and thought', and, reciprocally, 'Through beauty, the spiritual person is led to nature and rendered to the world of the senses' (1967: 123). The mediation of the beautiful operates henceforth, impartially, from one as from the other side.

Does it lead to a solution? No. Because once the surpassing of the one sacrificing itself to the other is no longer implied, this 'middle course' of the beautiful lays claim to bringing together what is irreconcilable, and this mediation which the beautiful alone can effect as it places us in this middle state (*mittlere Zusland*), uniting two opposed regimes, from that moment can only reinforce the contradictions. This is because, if the beautiful links these two adverse states of sensibility and thought, 'there exists nothing,' continues Schiller, 'that can conceivably mediate between

them'; thus they would be unable to blend in any way: 'This is precisely the point on which the question of beauty must eventually turn' (ibid.). The beautiful is indestructibly the 'problem'. For want of constructing this mediation anew, as Kant did from a theory of the faculties, it follows that we will always return to it, when all is said and done, as the vestige of a stampede but one which creates a hole in European rationality (but desire and fascination are also swallowed up in this breach), in the 'enigmatic' nature of the beautiful. In it, the 'Mystery' would be condensed

Is it possible to emerge from this impasse? Could one ever take oneself outside this conception of the beautiful as union-mediation of two separated, even opposed, realms in respect of their essence and so focus on the contradiction within it? Hegel would rather appear to return to it, since the work of 'fine art' still here holds the 'middle', between the immediately sensible being and ideal thought: in it, the beautiful is thought as that knowledge in the form of the sensible and the objective at the core of which the absolute of the supra-sensible gains access to sensation, whether it can therefore be defined as the unity of the (universal) concept and of the (individual) phenomenal manifestation, or from a 'content' and its 'manifestation' (*Inhalt-Äusserung*). This nevertheless

does not satisfy Hegel. Because just as he leads this conception to its completion, he brings in what undermines its very foundations; and of course he can only do this by bringing the renowned dualism into question. Through this divergence, I believe, he finally and discreetly opens the door onto something quite different.

Indeed, let us, along with Hegel, consider that the 'appearance' (*der Schein*) is no longer opposed to Being and truth but that it is henceforth the 'appearance' that is necessary to Being and without it truth would not exist (1986: 28); the beautiful itself is then the sensible appearance of the Idea (*das Sinnlichte Scheinen der Idee*). Let us then consider, in the same way, that the 'mind' has ceased to be an abstract entity cast into the 'beyond' of objectality (of what 'stands facing us', *Gagenständlichkeit* (ibid.: 139) but that it inhabits its other, which for it is nature, without allowing itself any longer to be limited by it. And, reciprocally, that 'nature' is no longer to be set separately facing the mind, as it was in the dualism of metaphysics, but conceived as 'carrying [it] in itself', *in sich tragend* (ibid.: 128). What is it that from that point radically changes in these relations of mind and nature if, although being differentiated, they are no longer considered external to each other, like two separated

'sides', in the way classical understanding has done by persisting for such a long time with the dichotomous? There is, therefore, discerned in this culmination of idealism with which Hegel ends a branching off which we can begin to follow in order to emerge from the very conditions of metaphysics, and even into which we can immerse ourselves. Idealism is now radicalized to such a point that it unmakes dualism, casting a first bridge towards something quite different, notably towards the conception that we have begun to locate in China and which will lead us, without dissociating nature from the mind, towards what we too will no less call the 'spirit of the landscape'. This reconfiguration of 'spirit', *Geist*, is a first step in this direction. But already, in doing so, and without even taking account of it, we have left the 'beautiful' behind us.

VIII

TO 'TRANSMIT THE SPIRIT' THROUGH THE TANGIBLE

A 'landscape': its summits and ravines, its rocks and forests, its mists rising from the vales and its torrents; or the immense bodies of water, a few islets vaguely glimpsed, and willows, on the bank, making visible the passage of the wind. How do these landscapes, among the vast number to have been painted in China by the brush of the cultured class, 'bear' within them, according to the Hegelian word, the infinity of the spirit? There is this massive physicality, these broad-tiered elevations, these heavy rocks, these rugged trunks; but they are there much as the actualization of an energy which at times becomes denser, hardens and is made opaque, and at other times dilutes, diffuses and becomes expansive. This materiality is not inert

but it allows the thrust which makes it happen to become apparent. The slightest contrast creates an exchange within them—they extend this materiality and render it active. What, then, does the 'spirit of a landscape' mean once it ceases merely to be, by simple projection and metaphorization, as it has habitually been considered in Europe, the transposition of the state of mind of a subject (which alone 'lends' them life) into things which would only be 'things'?

Some of the formulations engaged with in the earliest texts in China (in the sixth and seventh centuries, by Zong Bing and Wang Wei) devoted to landscape painting place us in this way on the path of what can only once more immediately question both our physics and our metaphysics. Let us not forget, moreover, that what is here translated as 'landscape' ('mountain-water(s)', *shan-shui*), far from offering itself to the unitary perception of a subject, whose gaze carves up the horizon, speaks in an exemplary way of this play of polarities, those not only of High and Low but also of the vertical and the horizontal, of what has form (the mountain) and what has no form (the water), of the motionless and the mobile, of the opaque and the transparent.... The landscape thus condenses and concentrates in itself the interactions which continuously weave the world and

inhabit it—which *animate* it. This is why it is said that 'the landscape really contains materiality within itself but tends towards the spiritual' (*Zhi you er qu ling*; Zong Bing in Yu Jianhua 1996: 583). Thus the Sage and the Landscape are effectively placed in parallel in China: 'The Sage through his spirit gives the norm of the Way, *tao*, and people of good will understand'; just as 'the landscape through its sensible actualization renders the Way agreeable and people enamoured with humanity take pleasure in it'.

Let us, consequently, pause at what is at this point far more than a balancing and promotes the landscape as a *way of wisdom*. Why does this 'physical actualization' (*xing*, 形) of mountains and waters, far from opposing the 'dimension of spirit' (*shen*, 神) through its inert perceptive-objective character, as nature ordinarily does in a European context, render sensible (agreeable and appealing as it is called) the teaching of the Spirit (understood more precisely, in this age and in this context, as Buddhist teaching)? Without blunting these formulations by our concepts, let us read further into them, to where *the conditions of the dualism are dissolved*: 'The spirit, which is rooted in what has no extremities, accommodates itself within sensible actualizations and affects/is affected according to the categories of things. Also, the internal coherence (*li*) penetrates even shadows and traces' (ibid.)

It is true that, as I translate it in this way, I am articulating and constructing too much (with articles, propositions, pronouns, relatives, subject and conjugation)—in rendering each of these formulations one should limit oneself to its four words (accommodation, actualization(s), affect and category/categories; *qi xing gan lei*). Moreover, this subterranean disturbance of our conceptions appears so much more discreetly at first because it is massive. But I imagine that already we perceive to where the divergence points, from below this syntactical coating, and what major displacement it operates. It is really a question here of a dimension of spirit (*shen*), which as such is invisible but not situated apart—it 'accommodates itself' or 'installs itself' (*qi*) *nowhere other than within* the sensible world; it remains actively involved in reciprocal stimulations engendering the process of things instead of detaching itself from them. This is why, while the Sage(s), it is said, shine(s) over innumerable generations, the ten thousand phenomena (*qu*, in the sense of the Buddhist *visaya*) 'melts the soaring of their thought' (*rong qui shense*). One will then ask, penetrating hesitantly into parallelism: How can the physical (the tangible) 'melt' with the (spiritual) ideal? Or what can such a 'melting' alone offer us that is more firmly fixed or more implicated, more originating, which would immediately be betrayed by all our

'visions of the world'? If this is indeed not a matter of exotic politeness . . .

I readily recognize that this question will be posed from the (Western) exterior, implying an alternative, while the Chinese thinker does not question but takes apart our antinomies in a casual way and without reflecting on them. One reason more for us to pause here. What does this 'melting' (*rong*, 融) suddenly unveil of another possibility, this ideogram evoking warm vapours which rise and dissipate and, consequently, any form of fusion, liquefaction or conciliation? To 'melt' thus speaks of the *transition* where the physical (the opaque) dissolves and opens out, makes itself indistinct and becomes expansive. And opens itself up to the imperceptible and the unlimited—to 'melt' is the anti-dualist word par excellence. With this formulation, so free-flowing in Chinese, let us therefore probe what it does not express and that it borders cheerfully and unperturbed. Let us think about it in this divergence that it incidentally opens up without further warning: the physical (the sensible) is no longer the other separated from thought, like two distinct 'domains' (according to the definitive formulation of classical dualism, *res extensa / res cogitans*), but 'melting' it, or it melting in itself, and allowing it to 'exhale', suppresses right away all exteriority of principle between them. A simple

variant with the other thinker (in holding to the only certain part of the statement): 'What becomes rooted in sensible actualizations melts [in itself] the spiritual' (*ben hu xing zhe rong ling*—ibid.: 585). This notional syntagm is therefore well typified. Or, again, as the *Shitao* said in similar terms, at the end of this pictorial tradition (the end of the thirteenth century): the landscape (mountains–waters) offers [presents] the spiritual (*jian ling*) (see Shitao 1984: Chapters 6 , 'Yen wan'; 13, 'Hai tao'; and 18, 'Zi ren'). Or, considering the two terms of the polarity apart but in parallel, the sea 'can offer the spiritual through its animation' and the mountain 'can carry along its pulsation'.

In (imported) European terms, the question is thus, really, disfiguring our metaphysics, how one can conceive of the distinction between the sensible and the spiritual without being led into the dualism upon which the 'beautiful' is perched. It will then be recalled, in a general way, that the Chinese, thinking not in terms of Being but of the process of things; not in terms of qualities but of capacities (*de*); not in terms of modelling and imitation but of circulation and viability (*tao*); effectively conceiving at the beginning only of a single and identical reality—the animating energy or the *qi*, 气 (*li*, 理, the other term in partnership with it during the classic era and that we ordinarily translate as 'reason', is the 'veining' or internal

coherence which allows the regulated deployment of this energy). Everything that exists, consequently, man as much as the mountain, is an individuation–concentration, or an actualization, of this energy–breath in its invisible foundation (*tai-xu*, 太虛) and conferring on it its tangible form.

But that, I fear, is too quickly stated; it is purely explanatory. When it is a question here, in our mind, not of intelligence but of *assimilation* (or of disassimilation and re-assimilation, by habituation, of what lays the foundation of our most common representations, sedimenting itself 'as evidence'). Let us therefore have the patience for this necessary acculturation, let us take time, I repeat, for this accommodation—the spiritual dimension (*shen*) and the sensible actualization (*xing*) will no longer be simply two opposed and complementary modes (in constant interaction) of this very deployment of energy. If there is, therefore, no 'spirit' and 'matter', as two separated entities, it is because we are in fact dealing only with operations: of spiritualization on the one hand and of materialization on the other, in continuous transition from one to the other and activating one another reciprocally. 'Spirit' is thus understood as when we speak of the 'spirit of wine': decanting, subtilizing and volatalizing to the point of imperceptibility (why,

moreover, in Europe, have we separated these two meanings of 'spirit'; physical on the one hand and religious and philosophical on the other?). Either this same energy condenses, concentrates and forms the tangible, a concrete that is concretion (where the opacity of bodies comes from: the *yin* movement) or it correlatively melts, spreads, animates and forms the 'spirit' (as a communicating and regulating capacity: the *yang* movement). But the two remain indivisible and cooperate in the advent of all reality, to the point that the energetic artery structuring the mountain relief, which geomancy examines, is given the same term (*mai*, 脈) as that by which the vital pulsation is transmitted (and with which the acupuncturist is concerned) in the interior of the human body.

There then begins to appear, slowly elucidating itself, that which at first sight would no doubt not have made sense—these first texts on Chinese landscape painting say nothing about 'the beautiful'. But I wonder: Why would they have needed the 'beautiful', and would it be a stake for them? Because if there is no separation of principle between the sensible and the spiritual, why would the intervention of the beautiful be necessary, attaching as it does one to the other and serving as union and mediation between them, so causing the spiritual to penetrate the heart of sensible

matter as it opens up the sensible to the elsewhere of the Idea? Through its tensions between the Mountain and the Water, the landscape engenders, 'offers', 'founds' the spiritual, it is said in Chinese, decants it, releases it and allows it to 'emanate', and this sole determination is enough. The animating energy (*qi*) is deployed in it in the very terms of its polarities; at once concentrating opacity in the sides of the mountain and overflowing with fervour in its summits and its torrents, or spread in sparse mists, veiling even proximity from afar and opening the configuration onto the unlimited. The mountain is a condensation of energy to itself alone, described to us like the body of the dragon, in rising up and withdrawing, in yielding and bending, in mingling the inert with the agile, the solid with the sharp, the rocky and the grassy, the dense and the sparse, the deserted and the inhabited. . . . It 'acquires physicality by how it is seated' at the same time as it 'offers animation through its spirituality', 'becomes shadowy through its transformations', 'through its humanity the spirit is divested of obfuscation, 'stretches in contrasted lines by its movement,' and so on (*Shitao*, Li Wancai 1996: Chapter 18).

Nevertheless, hardly have we started to read this passage in which Shitao says how inexhaustibly the mountain assumes the 'burdens' (the 'functions', *ren*)

it receives from Heaven (nature) than every time something soon manages to resist us. But are we be able to say what? I have often returned to this page with a feeling of discomfort that is difficult to dispel (Ryckmans, the translator, though, makes almost no comment about this chapter). Let us not neglect this discomfort: we see in it only a personification which consequently appears to us outrageous (is it some 'Oriental' mannerism?). This spiritual that is released from the mountain results neither from a mystical fusion (by renunciation of the principle of individuation and identification of the self in the world), nor is it simply metaphorical, arising out of a transposition of human aptitudes and feelings into the landscape. And it is there that we leave Hegel, since he took only the first step in this direction. 'Natural beauty,' said Hegel, then comes from the fact that it 'provokes in our intimate being (*Gemüt*) certain states of soul (*Stimmungen*) with which it finds itself in accord' (1986: 177). Although reconfiguring the notion of spirit to the point of no longer making it the other separated from nature, Hegel, approaching the landscape, retains the conception of a romantic projection and 'sympathy' (of *Zusammenstimmen*)— 'beauty' then stems from the echo which the interiority of a subject finds in external spectacle. It emerges, in

other words, from this other union and mediation operating between the subjective and the objective, and whose opposition by Hegel is not for all that raised here. In contrast, in the conception developed by Shitao, the 'spiritual', or 'life', is not at all 'lent' to the landscape but *emanates* and activates itself, as I have said, from its own tensions, those that just as much put to work the brush of the painter in actualizing the vital energy in his drawing (*Shitao*, Li Wancai 1996: Chapter 6, 'Yun Wan').

Thus one commonly finds in *Arts of Painting*, in lieu of the beautiful, but without it becoming hegemonic and making claim to be a concept, a notion that could be translated most literally as 'spiritual colouring' (*shen cai*). It expresses most especially the means by which the sensible 'spreads' or 'transmits' the spirit (*chuan shen*); how also, reciprocally, this sensible world allows itself to be passed through and deployed by it. Let us not forget, moreover, that, in its genesis, the notion has served to evoke the detached, noble 'atmosphere', from a personage, such that it impregnates its slightest traits and emanates from its whole appearance, allowing the appearance—like an inexhaustible fund—of its internal quality and elevation (see, for example, Mi Fu in Yu Jianhua 1996: 459). The same thing also goes for the 'wind' (forming a

partnership with the spirit, *fēng-shen*). In painting, these are notably mists and light clouds decanting the materiality and opacity of things which furnish the representation with 'spiritual coloration' (see, for example, Guo Xi 1960: 22). Whether it would be a question of the swaying body of the dragon showing through the clouds, or the prompting animating the paintbrush and rendering his line expressive (for example, Mi Fu in Yu Jianhua 1996: 459–60), this term always indicates that, as the opacity *melts*, the invisible diffuses into an aura and will give an iridescent form to the sensible manifestation—not therefore the manifest and obvious (vulgar) brilliance, not living, not moving, disclosing itself on the surface and quickly exhausted (ibid.: 460), but that which lets show through in a diffuse way (not limited, not assigned) the foundations animating things.

This is also why we read, in the course of these *Arts of Painting*, that 'it is easy to paint form', but 'to paint the dimension of spirit is difficult' (Yuan Wen in ibid.: 70). Form, it is said, is 'physical form' (*xing-ti*, 形体), the dimension of spirit is 'spiritual coloration' (*shen-cai*, 神彩), 'In a general way, concerning the physical form of man, those who currently study painting arrive at this point; but concerning spiritual coloration, at least to overcome others in its interiority, one does

not succeed in it.' Even concerning the painting of horses or flowers, there are those who 'overcome by the form' as there are those who 'overcome by the spirit'; there are those who are 'content to trace the form' and those who 'transmit the spirit'. It is again necessary to be clear about what is understood here as 'form' (*xing*, 形), and which I have rendered most often until now as physical or tangible 'actualization'—it is form as energetic formation, that in which the dynamism of things, in their process of arrival, is concretized, and not the model, ideal, paradigmatic (ontological) form, on which the Greeks founded the beautiful.

IX

BEAUTY COMES FROM FORM

When we look at the preparatory drawings of Leonardo and see how the pencil, through successive attempts, seeks out the form, how he made the possibilities vary as much as possible and for a long time came close to a solid line, before eventually stopping at the correct, exact and definitive form, as though it had suddenly imposed itself, from which point there will be no question of returning, we understand how the Greeks had so soon made the triumph of *form* the very definition of the beautiful and, still more, how they had seen in this emergence of the final, ideal form, an access to a completely different thing— suddenly the absolute is in-carnated (as though it could come only from elsewhere, pre-existing all these attempts). And as though it had suddenly fallen

directly onto it, the pencil, after so many preparatory assaults, had captured the refinement of it in its line. How many rejections were behind all the preceding hesitations before this rigour was suddenly imposed . . . ? It alone is finally real. Under this almost imperceptible form, from one pencil stroke to the next, to the final, the ultimate one, a breach is opened up.

This form at which Leonardo stopped is no longer satisfying just because of its sensible aspect due to this optimum it has realized in terms of dimension, proportion, curvature or extension but, in attaining what suddenly emerges as unsurpassable perfection, in effect it falls into a completely different 'realm'. A qualitative leap has taken place which pushes out the indefinitely perfectible and, breaking at a stroke with the preceding hesitations, makes visible the sharp edge of a truth. It will be said that this truth 'dazzles', according to the common metaphor, the one inherited from the Greeks. But to what extent is it really a question of a metaphor, and is it one that can be avoided? How can one express what is suddenly and abruptly detached, by its distinctness, from everything approximate and consequently relative, and revealed to be alien—and that can best be labelled as 'ideal'? This ideal form which creates beauty arises from a necessity which no longer has anything empirical

about it and, causing all the other possibilities that have been tried to surge back like so many shadows or reflections, whose sudden inconsistency appears in a crude way, is accentuated owing to its 'clarity'. It is no longer part of becoming. It is now anchored in Being. Even in this drawing of fragile flesh, it touches on what the Greeks named Eternity. A whole onto-logical arsenal has been justified at a stroke.

Suddenly, and this is where beauty is differentiated, whether we commonly say 'it's beautiful' or, rather, that we can no longer refrain from saying so, from crying out, from the sensible framed integrally with the intelligible, the one confirms the other exactly and the two levels are henceforth in alignment. In this sensible form, as if from an indentation, the beyond of the intelligible has left its Empyrian domain to manifest itself. Thus, what the beautiful form has suddenly placed its hand upon no longer has anything of the quality of a thing—a particular, anecdotal and fundamentally blurred 'thing' as things are indiffer-ently—but 'is' an *essence*. This is isolated from the continual flux of actualizations as they ceaselessly transform and reconfigure themselves. The beautiful form effectively *stops*—the pencil emerges from its long fumbling and cannot go any further. This beau-tiful form alone attests to the validity of metaphysics

and gives rise to its fertile and not artificial 'hypo-thesis' (of an unfolding of levels). For the metaphysic is then no longer so much this interpretation of the world which has been so costly to us because of its dualism, scorning the senses and slandering life (its so-called asceticism), in which the Greeks entan-gled us, as it is obligatory to give an account of this experience—a Form is suddenly imposed from these laborious and hazardous fumblings that is exclusive of any other, that definitively leaves contingency behind, and whose legitimacy is not allowed to be contaminated or even measured by anything. This is why the metaphysic treats Beauty in an essential way and not as one subject among others. The Greeks (Plotinus) have illuminated this truth for us.

The thought of the beautiful was developed in Greece in the concept of a *form* which is at the same time *essence-idea*, *eidos*, and with which the artist, taking it as a model, tries to model the concrete. Plotinus made it into a controlling thesis. Refuting the Stoics, for whom beauty could only ensue from correct proportion and the 'symmetry' of parts in combination with one another, Plotinus says that beauty, above all the beauty of the body can reside only in 'communion' in this Idea-Form (*metochè eidous*) (Plotinus, *Enneads*: I, 6). In contrast, everything is ugly 'that has not been

entirely mastered by form, that is by Reason' (ibid.): form and reason constitute a pair (*eidos-logos*) since they reveal the same exigency coming from this coherence that lies beyond the sensible world and in-forms it. 'Therefore Form approaches and orders the multiple parts from which a being is made as it combines them' (ibid.). On the other hand, we would judge that some things are beautiful depending on this form that serves as a 'canonical' rule, as we discover in its spirit—the artist will be content with 'adjusting' the external house to the form of the house which is in it to pronounce that it is beautiful. Because the external being of the house is itself, 'the stones apart', only this interior form, form-idea— 'stamped upon the mass of exterior matter' and 'the indivisible exhibited in diversity'.

This is already the case for natural beauties. Is not 'form' traditionally opposed to 'colour'? Even the beauty of a simple colour coming from a 'configuration' (*morphē*) dominating the darkness of matter and, through it, the presence of an 'incorporeal light' which is 'reason and form' (*logos-eidos*—ibid.). Of all bodies, fire is the nearest to this; therefore it is the most beautiful, casting the greatest illumination and, not subject to contamination, it 'touches upon the incorporeal'. This could well be said of sounds too—

sounds are beautiful, in their numbers and their mea-
sures, insofar as they are subordinated to the sovereign
action of Form whose harmony does not belong to
the sensible world. 'What then is beauty?' they will
persevere in asking over and over again, with a view
to isolating it more effectively. It will certainly not be
found in the flesh, responds Plotinus: 'neither in the
blood nor in the menstrual blood', no more than in
the complexion which differs in each person; nor even
in the form of the body, a simple outline (*schema*),
necessary as it is to separate the internal form of
beauty, the form of the intelligible, form-idea, from
this simple shape. Because (let us recall Plato), beauty
is 'shapeless', since shape fatally reduces it to what
is external, to the partial and the relative (it is *a-
schemon*); it simply 'envelops' the diffuse 'matter' in
order to fashion it.

This could equally well be said for art in general.
Plotinus was the first person in the West to conceive
of Art as devoted to beauty. Against the (Platonic)
idea that the arts could only be an imitation of nature,
he points out, in a decisive way, that the arts know
how to rise to the 'reasons' (*logoi*), from which nature
itself is derived, and they possess beauty in themselves
(ibid.: V, 8, 1). But from where does the beauty of art
come? Plotinus answers: The statue is beautiful not

because it is stone, but owing to the *form* the artist sees in his mind and introduces into the stone—insofar as he can introduce it—because 'beauty in art is far superior' (ibid.). The more it goes towards matter as it extends itself in space and externalizes itself, the weaker it becomes. What then is art, according to this image becoming a matrix and which will dominate European thought, if not the desperate and dramatic battle in which each artist comes to engage in order to enable pure Form to triumph over 'amorphous' matter, a dark, resistant and opaque matter, and submit this obscure 'mass' to the light and its transparency (*eidos*/*onkos*)?

In this way step by step, by successive outlines producing a slow accommodation, the divergence is clarified in which we started to enter and could not measure all at once (the relation between China and Greece, as I warned at the outset, is still to be constructed). Enough has even perhaps already been said about it, so that we could raise the apparent ambiguity in the conception of 'form'. What, on the whole, opposes the form-idea of the Greeks (*eidos*) to form as actualization of energy (*xing*), as it is conceived in China? Above all, the former exists entirely and independently of the matter which receives it. Equally, instead of occurring as a temporary formation, it

exists, as one, eternal and true. All the attributes of metaphysics are adapted to it. Equally, since beauty is entirely on the side of such 'form', the form in reply will express what is isolatable about beauty and characteristically belongs to it. Whether it is question of a Greek choice, or of what I call a *fold*, largely going beyond scholarly debates, which henceforth appear secondary, can be verified from the fact that the Greeks have never emerged from it. Even if he ceased to believe in the existence of forms separated from the sensible world, Aristotle no less extended the status of this metaphysical form which gives it existence—neither engendered nor corruptible, but transmitting itself identically from the engenderer to the engendered it is, as such, unalterable (and therefore being confused with 'quiddity'—Aristotle, *Metaphysics*: Zeta 3–8). Although not allowing itself to be detached from the individual, such a form is not for all that something individual but remains an ideal configuration, *schema tes ideas*. At the same time, everything that has reality within the individual, Aristotle says, is constituted by this form-idea which is therefore more immediately substance than the individual itself, composed as it is of matter and form. Let us then go back to art, above all to sculpture, which for the Greeks had the value of a model—it is

such a final form, present in the soul of the artist before passing into matter which is judged by the efficient—sufficient—'cause' of the statue.

The Greeks therefore teach us this above all: when, looking at a statue, we judge it to be 'beautiful', we mean that, considering its sensible form, it does not for all that belong to the sensible realm. Its form detaches it from the dispersion of the sensible and promotes it to another level (that of 'Being', of the 'eternal', of the 'intelligible' and so on). Because in limiting the sensible and circumscribing and containing it, by means of the chisel or the line, the form reveals in it the submission of the sensible to the idea, which itself is delimitation and 'definition' (*horismos*) in which the idea is effectively 'form'. The statue is beautiful in proportion to this submission or, rather, it is only truly beautiful if nothing more within it can harm the injunction and delimitation of the form-idea. 'Form' thus communicates from within, as *species* or *forma* in the Latin of Augustine, these two points of the (ideal) form-definition and of the (material) form-outline, linking the (plastic) aesthetic sense to the ontological sense, *eidos* and *schema*: between the form constituted by the harmony of parts in relation to one another, *concordia partium*, at which the Stoics wrongly stopped, and the unitary form (*forma unitatis*), informing and

distinguishing, which is its principle and, as such, leads it out of the confusion inherent to the sensible world. This is because 'form' causes to circulate from one to the other the fact that the beautiful can, through form, link the sensible and the intelligible, so that the latter suddenly appears in the heart of the former and fulfils its (structural) role of mediation.

Classical philosophy will follow according to these two angles—once again there is 'tradition', so burdensome to move despite what is newly discovered in it from the point of view of an operativity of the subject. On the one hand, by opposing form to 'matter', which is rejected as unworthy of intervening in the judgement of the beautiful; on the other hand, by distinguishing form from 'shape' which is only an external and partial manifestation of it. Let us look again at those Kantian distinctions which separated form in this way from two sides ('Analysis of the Beautiful' in Kant 1978: §10–17). On the one hand, while the matter of sensation furnishes only charm or 'attractiveness' which, as such, remain external to the beautiful owing to their character of interest, the judgement of the beautiful cannot be 'pure', that is, non-empirical, except by its 'form' which alone renders it universally communicable. On the other hand, the form is not limited to the shape; it overflows it as

it extends it equally to the 'play' of shapes or sensations, whether this would be in space or time (mime, dance or music), arising then not from the drawing but from the composition, and form is especially elaborated and constituted, as a representation of the spirit, as a principle of liaison and unification of the diverse, that of perception, and this according to the schematizing activity of the imagination (in relation to the understanding); it could not then be limited to its phenomenal manifestation alone. Thus the satisfaction taken in form, in one way as in another, Kant concludes, will beneficially separate the beautiful from the pleasure of the senses.

More still (the point most developed by Kant): if one wants to ensure the autonomy of the beautiful (and of art with it), the finality of the beautiful could not be given a subjective end, which would make it immediately lapse into the 'agreeable' (arising from matter and sensation); nor could it any more have an objective end, which would imply a concept and consequently be a matter of knowledge, which would confuse it with the 'good' and perfection. Now, to emerge from this alternative and think through what from that point ceases to be just a 'finality without an end', Kant returned to the virtue of the *formal*: as we know, the beautiful can be just a 'form of finality', free,

as such, from any determined end, something which would inevitably cause the satisfaction it aroused to fall back, from one side as from the other, into 'interest'. Here therefore Form once again saves the beautiful on every front, withdrawing it into its essence, even preserving it obsessively from all corruption or confusion. It isolates and maintains it as *pure*. Such 'purity', from the time of the Greeks, has really been the principle of the beautiful. Also, even from the point of view of its objects, beauty must remain free, 'vague' (*vaga*), Kant tells us, rather than adherent—it must therefore remain independent from anything that would condition it. What really remains essential, for the beautiful, is to stand indemnified from anything that would implicate it in the other: from the order of attraction, uses, functions and even, Kant maintains, emotion. Through *form* the Beautiful haunts the world without compromising itself in it—and perhaps even without inhabiting it; in any case, without being integrated into it. It remains alien to it.

X

OR TO PAINT THE TRANSFORMATION

The Greeks dreamt in this way of the 'beautiful' form being revealed beyond the confusion and indefinition of the sensible and the properly 'metaphysical'—Form emerging victorious from the heart of the approximation of things through its exactness, imposing itself by its intelligible determinations alone which, once having appeared, would be unalterable and entirely 'existing'. What can result, in a flashing way, from what it leads in this way to touch explosively, this 'envelopment' of matter by form, opposed as they are? The Greeks projected onto this abstraction of pure form nothing less than the craving of the philosophical *erôs* engaging to possess this ideal projection on earth and in the flesh. As though, triumphing with opaque shadows, the artist finally embraced, in this

Form, the coveted body of the divinity. As Plotinus says: 'Phidias wrought the Zeus upon no model among things of sense but by apprehending what force Zeus must take if he chose to become manifest to sight (*Enneads*: V, 8, 1). The athlete launching himself to throw the disc or the changing play of the light of day on the cathedral:—art renders even these most fleeting or, rather, impossible poses 'beautiful' by stopping them (eternalizing them) in these most ephemeral moments. Through form, the beautiful turns everything it touches into an essence, as Midas did of gold, and because the form holds this quality separately from sensible matter, the beautiful can be *isolated*.

Let us now consider what is too conventionally (substantially) called the 'real' (*res*: the 'thing'), no longer in relation to Being that is incorruptible because alien to becoming, but as this energy renewing itself ceaselessly thanks to the coherence of factors regulating it internally (*qi* and *li*, the great Chinese alliance). What is commonly translated as 'form' (*xing*) is now simply this temporary actualization 'assembling' itself and 'taking itself apart' (*ju/san*, 聚 散) emerging from primitive indifferentiation in order to plunge back into it: oscillating between agrément the reifying concretization and the animating expansion: between the

densification and decantation; between the opacifi-
cation and the clarification: henceforth, from one
state to another, one no longer has to deal with any-
thing except *transitions*. There is no longer the dark-
ness of matter on the one hand, and the eternal light
spreading Form on the other. How, and in relation to
what, could this agglomeration of energy be isolated?
It is the manifestation of no external order in the
world. If 'coherence' there is, it is to be taken in the
literal sense as what holds together this concentration
of energy and maintains it in operation through the
equilibrium of implied factors, *yin* and *yang*, and it is
a question of the nature of humanity as well as that
of the mountain. Not being separable from anything,
not even by thought, how could some appropriate
charter be extracted from it, the normative existence
of which would be definitive and upon which the
beautiful might be perched? Outside ontology, we
would no longer encounter (self-consistent) Forms
but only phenomena of *trans*-formation.

To paint, in China, will therefore be to bring to
light, through what is displayed and what reifies, the
internal process which causes it to come about and
change role, so releasing its dimension of 'spirit' in
rendering sensible not qualities but capacities; it is
not the inventiveness of a composition ('symmetry',

proportions, and behind them geometry) but interactions in which one mark engenders the other by 'attraction and repulsion' (*xiang-bei*). Nor is it a matter of emphasizing contrasts and complementarities but of bringing polarities into play (more technically, according to the classic pair in China: to reveal the 'functioning' or *ti-yong* through 'physicality'). This phrase, which I take from the work of a man of letters from the Song era (Qian Wenshi in Yu Jianhua 1996: 84) suffices to express this in a universal way: 'The mountain below the rain or the mountain at times of clear weather are easy for the painter to represent.' In fact, anything which is determined and stabilized, with designated and typified features, is petrified and of little interest. 'But the time when fine weather tends towards rain, or rain tends towards the return of fine weather [(*ji*), indicates with a single character that, as the rain stops, so the sky clears], to shelter the evening in the heart of the mists, [when] what has been dispersed gathers once more and things plunge into confusion: the emerging/immersing, the between there it is and there it is not—this is what is difficult to represent.' 'Easy'/'difficult' are here the markers of a graduation. Rather than portray distinct states, at once sharp and opposed, and always threatened with lapsing into cliché (in the rain or during fine weather

or in the full light of day), the Chinese painter paints modifications: *between* dissolution and concentration; between emergence, which renders prominent, and immersion, which confuses; between the 'there is' of actualization and the 'there is not' of the return to the undifferentiated (*you wu*, 有无). No form stabilizes, no *eidos* is isolated. From what point, then, could the 'beautiful' be detached in order to affirm, in the heart of what is continually *in process*, a distinctive 'being'?

This is why the Chinese painter does not paint a landscape as it could be offered to our perceptions, but, rather, the 'tensions' at work in the 'configuration' of every landscape (the notion of *xíng-shì*), from where it takes its coherence and its animation. It is necessary to take the measure of Heaven and Earth, says Shitao, at once in the 'altitude' and 'clarity' of the one and in the 'extent' and 'consistency' of the other, 'to be in the position of modifying-transforming the unfathomable quality of mountains and waters' (*bian-hua shan-chuan zhi bu ce*, see Shitao 1984: Chapter 8). A landscape is consequently never a corner of nature but concentrates within itself a whole play of complementary oppositions through which, even on its vast scale, the world is impelled to expand and renew itself. What is a landscape if is it not that inexhaustible resource of transformation which the variations of ink

and the inflections of the brush seek to bring out and express? To 'probe' (*ce*) is the appropriate word—the painter explores through various formations arising under his brush those foundations without foundation from which they ceaselessly emanate. He does not strive to draw a sensitive or constructive truth from it (as from the Impressionists to Cézanne), nor does he want to cause a quality (a tonality), harmonic and 'beautiful', to triumph from the depth of things, because beauty is always *resultative*—it is the result of so many sketched attempts and it hoists this final and definitive state into the timeless. But, through this continual engendering of representation, the painter, Shitao tells us, gives proof of 'life' in its blossoming.

It is true that the difference of means should be taken into account: not the form and colour (*schema/chrôma*), but the 'ink and the brush' forming a couple whose complementarity is consequently generative—polarity once again. Not the colour, the dry substance, the thick material, but the more or less diluted ink, varying between the clear and the dark and letting itself be absorbed in a diffuse way, as an aura; not form purified by the drawing and becoming ideal, but the brush with a supple tip oscillating continually, pressing down or lifted, making leaps or reined in, curving or sharp, conducted from a 'full wrist'

which allows it to work into it or an 'empty wrist' which makes it 'fly and dance', and which never goes back over its marks. This brush, 'evolving and pivoting', ceaselessly 'modifying' its course so as to renew its dynamism and to 'continue' to advance (*bian-tong*, 变通) escapes getting bogged down in that which would then inevitably be 'materiality' or 'form' completely actualized and become rigid (*bu zhi bu xing*; Jing Hao, 'Bifa Ji' in Guo Xi 1960: 22).

Speaking of Huang Gongwang: 'his tintings and blurrings of ink marvellously succeed in grasping the work of natural transformation'; or of Ni Zan: 'from the alternation of the dense and the sparse', 'of the dark and the diluted', is spread 'the modification—transformation on every side' (in Fang Xun 1962: 114, 150). Or again, what distinguishes an accomplished painter from an ordinary one is that he is not limited to application in the use of ink and brush but 'knows how to transform both' in such a way that if, in each place, the painter has expended effort and has conformed to the rules, what is nevertheless perceived afterwards is only a 'device of transformation' (this is how I would render most precisely *hua ji*); what is then attained is the 'summit of painting' (in ibid.: 29). *Device* of / in *transformation* conveys effectively what makes for the originality of the painting by the

literati. He emanates, we are told again and again, an impression of 'life'; not the beautiful but, we constantly have to return to the fact, a dimension of 'spirit' (*shen-ming*—ibid.: 114, 150).

We could otherwise be amazed by this definition from the *Shitao* that has to be read literally: painting is 'below the heavens', or in the world, 'the great rule of modification-continuation' (Li Wancai 1996: Chapter 3). Because pain-ting is what allows, as it starts with the elementary first feature and infinitely 'modifies' it, the portrayal of the extreme variation of things without anything being stereotyped; as, in returning to this originating feature, to 'transform' this fundamental unity into a new source of figurative engendering. The two form a couple, 'modification' and 'transformation' (Chapters 6 and 7). The painter, in releasing himself from sinking into vulgarity, is capable of 'modification'; as, in releasing himself from the obstruction in opacity, he is capable of 'transformation' (Chapter 16). Or again: if the Heavens invested man with this first stroke cutting into the original confusion, it does not for all that invest him with its 'modification', which it is the responsibility of man to develop' (Chapter 17). The French translator Ryckmans is wrong on each occasion to render 'modify' or 'transform' by the word 'creation' (Shitao

1984: 117, 126). In going back to the Western repre-
sentation of Creation, we once again assume that we
pass from non-being to being in shaping the defined
forms of things and that the resulting variety makes
the beauty of the world; while the process of contin-
uous engendering which the Chinese here describe for
us, whether in the course of the world or the tracing
of the brush, makes variation by alternation the suffi-
cient condition for all accession.

XI

VARIETY OR VARIANCE

There does nevertheless exist, in Europe itself, another position which sees the incarnation of an ideal form (Plato to Plotinus) in everything that is 'beautiful'. It does so by sticking to the phenomenal aspect of things, without 'assuming' an intangible world within them, and has withdrawn beauty from its metaphysical plinth: beauty then rises to the surface and blossoms; it extends in scale and diversity and reveals itself totally in sensorial manifestation. It even multiplies it—in this case, it will be defined as 'variety'. In opening out the innumerable folds of the sensible world, variety breaks its monotony. It does so no longer in relation to some transcendent norm but solely through the internal difference it has produced in it. Because it captures the gaze and holds it suspended on that

visible as it causes it to travel according to an appearance which, continuously renewing itself, never ceases to amaze. When we follow the notches on a leaf or the range of greens in a meadow, we will never tire of admiring the resources of an indefinitely ingenious nature in its invention.

The Stoics did not hesitate to draw from this source of wonder, one that is truly inexhaustible; they even drew an argument from it, being the first thinkers to develop a phenomenological approach against metaphysics, about what makes the world and the event. 'Variety' (*poikilia*; they themselves teach using *stoa poikilê*) in developing the greatest possible number of forms and colours, is for Chrysippe inseparable from the beautiful. By its amplitude it manifests the plenitude of a world which would otherwise be, by the repetition of the same, only a flat 'filling up', a sad mass. Does not such a shimmering play of differences extend the colours of the planets through various tones of the autumnal vegetation and to the point of the colourfulness of the nebris of Pan (Cornutus)? In Cicero, this *varietas* of the terrestrial fauna and flora is, through its largesse, enough to reveal divine generosity.

Equally, it is the part of classical philosophy which the Scottish empiricists did not fail to develop

in defining original beauty by an equation established at the heart of the sensible world rather than by an elevation to purity of form: *uniformity amidst variety*, says Hutcheson (1738: Section 2). A judgement is then made in the name of the 'agreeable' alone— where the uniformity of bodies is equal beauty is a function of variety as it emphasizes this uniformity. Both suffice by their quasi-mathematical composition to define where the attraction comes from. We already notice this from geometrical figures—here, beauty is augmented with the number of sides, at least as much as their proportions are still observable. Or the beauty of the universe showing a 'diversity as regular as it is agreeable' may be taken once again in evidence, and this is so even in the revolutions of the planets—to the point that the astronomer can indulge in tiresome calculations while being charmed by them. Equally on the earth, so 'beautifully diversified', it will be enough to observe, by following the inclines of the relief, the 'various degrees' of shadow and light.

Nevertheless, one should not be the dupe of this deliberated, and reiterated, plunging into the rhapsody of meanings and this sensible shimmering. However much it may represent the internal riches of the sensible world and no longer assume the founding background of the thing, variety does not any the less

maintain an identifying plinth for the thing—*something* (*quelque chose*, *ti*) really has its own and definitive being (whether it is a flower or the human body), whose variety *then* brings to light, in its unfurling, a possible diversity, of form or colour, that avoids stereotypes. This signifies that, if it no longer assumes a metaphysical essence, even valorizes itself from the fact of no longer making an appeal to the intangible world, *variety*, which is characteristic of this world and deploys it, implies no less an essence by definition—in other words, a 'logic'—which is that of the unitary genus diversifying itself in it, verifying once more that 'logic' is not neutral but implies an onto-logic. In relation to this, variety still manifests itself as being of the order of belonging, of the attribute and of the quality, even if it is only extended to secondary qualities—it is the quality that is scattered in proportion to how much the other determinations, suspending their exclusivity, leave that is vacant and undetermined. But this diversity, displayed as it is, does not for all that break with the permanence of primary qualities that define the genus, untouchable and posed in principle.

Against this is what I will call 'variance'. I define *variance* as the variety in which the essence of the thing dissipates: when the phenomenological approach negotiates a further step and the final mooring lines

are cut with 'quiddity'—which is then floating, or, if one likes, rambling, outside ontology. It is, one guesses, what Chinese painting exploits by predilection as it devotes itself to the 'modification-transformation' in which also once more it strays from beauty.

Let us consider the/a mountain. Or, rather, let us begin by withdrawing this article, definite or indefinite it doesn't matter, which Chinese does not have and which already individualizes and allows an essence to be outlined. 'Mountain' (*shan*): What pertinence can still be accorded to this nomination if the difference is no longer offered on a foundation of permanent features that 'assume' an identity for it? For one of the greatest Chinese painters and theoreticians (Guo Xi, in the ninth century), 'mountain' can serve only as a frame for the inventory of what I have just called *variance*. For him, 'mountain' is not an essence but a *rubric* (according to the great Chinese articulation, controlling the development of the concept, linking 'words' and 'things', *ming-shi*). Of 'mountain' in fact, this literati limits himself to telling us (Guo Xi 1960: I, 21): 'Considered from close up, it is like this: considered from further away, it is (in a different way) like this; considered still further away, it is even more (in a different way) like this'. 'This is what is called the form [actualization] of the mountain as it

modifies itself with each step.' Or, from the front, it is this; from the side, it is this in another way; from the back, it is even more another like this: 'This is what is called the form [actualization] of the mountain as it is seen from every side.' In consequence: 'Such is the appearance of a mountain at the same time as dozens or hundreds of mountains. Should we not be aware of it?' The consistency characteristic of the mountain does not now lie in anything other than the way in which all these different aspects are simultaneously contained, and maintained, in equality—the mountain is rich in making itself *available* to each of them and comprising them all (in this respect, it is also expressive of wisdom). Let us then consider it again from other angles. 'Mountain': to consider it in spring and in summer it is this; in autumn and in winter, it is another this (or in the morning it is this, in the evening another this, and so on): 'Such is the state of mind of one mountain and at the same time of dozens and hundreds of mountains. Can it not be explored?'

I have here translated as literally as possible in order not to risk falsifying the divergence arising unexpectedly as you follow the sentence—though how many times nevertheless have I reread it, uncertain about how to understand this 'at the same time' (*jian*)

which interrupts the exclusion between the plural and the singular? It could of course be ignored (sinologists usually do). But one can also stop at what suddenly casts confusion here and even see in it a seam to follow. It is then necessary to ask: What is there here which disappoints our logical expectation if not precisely that this diversity of aspects is no longer to be understood as a *variety* that presupposes a community (identity) of essence? Because it really appears here that the consistent aspect of things (of the mountain) encompasses and coordinates in itself the various cases without the plural any longer arranging itself under the singular, nor the species any longer respecting the hierarchy of genus. Then how could this be considered, given how difficult it is (in Europe) to think while relinquishing the identifying plinth of the 'thing', in other words, to place all essentialism between parentheses?

Nevertheless, let us again recall some of the characteristic evolutions of science and how my aim could start to be clarified by oblique forms of science. We know that modern physics has resolutely emerged from essentialist perspectives. As evidence there is what it calls 'multi-level' or 'multi-resolution'—when we represent an image no longer in a given resolution (as in terms of 'pixels') but through every possible

resolution at once. In allowing us to analyse an image by taking into account every level *at once*, this representation (in 'wavelets'—Morlet, Grosmann) allows, it has been shown to me, methods of compression of an image to be proposed which are indeed very much better.[4] I would not wish to misuse this parallel, but I believe that it is really such a 'compression' of the image that the Chinese theoretician-painter in his own way also has in mind: integrating every possible point of view in a single aspect whose continuance, consequently, is bound to internal variance and not to a given point of view, applied as constitutive of the essence and the other points of view of which would afterwards—but secondarily—develop the variety 'agreeably'.

Thus, to deploy this internal variance in the mountain, Guo Xi does not begin with a basic definition (a 'resolution') of the mountain but first of all arranges its contraries (1960: 20): in the south-east, the land is very low, rains bathe and denude it, the ground is thin and the waters are not very deep, and so on—Mount Hua rises up, not from the surface of the earth but from its entrails; in the north-west, the land in contrast is thick and fertile, the waters are deep and meandering, summits recur in uninterrupted chains, and so on—Mount Song comes from

the surface of the ground and not from the entrails of the earth. From these antipodes extending the extremes (let us not forget that 'thing' in Chinese is also expressed as 'east-west'), Guo Xi unfolds the multitude of aspects that the mountain conjointly contains and which form its plenitude: 'rising eminent'—'imposing itself arrogantly—'opening generously'—'squatting'—'spreading out' and so on (ibid.: 22). In a symptomatic way, the French translator has introduced as alternatives 'whether' or 'or', between these determinations, re-establishing a distributive variety that itself restores the exclusion (Vandier-Nicolas 1982: 93). But if Guo Xi warned in the heading of this enumeration that the mountain is a 'great thing' (*da wu*), it should be understood that 'great' here refers to the extent of what is compossible; one aspect is not being affirmed to the detriment of another but it is their amplitude that constitutes the complete-ness of the mountain—the mountain *at the same time* rising eminently, arrogantly imposing itself, opening itself generously, and so on. 'Great' has the same meaning here as when it is said, in the *Tao te Ching*, that 'the great square has no corners', as it does not limit itself to its limiting and exclusive form of the 'square' ('square-square': narrowly revealing—'small'—in the restrictive nature of the square; §41), or that the 'great image' 'has no form' (*da xiang wu xíng*).

The same thing goes for water—there is no essence of water, but its variance ('deep and serene', 'soft and smooth', 'swirling', 'oily', 'surging '. . .) renders it 'living'. Consequently, the painter does not aim to please the viewer's gaze by unfolding the variety of 'beautiful' things before him, because they mutually emphasize their contrasts and break the monotony. This is because the world is not for him a spectacle whose diversity intrigues and captivates the desire for novelty; one indeed in which the prodigious richness at the heart of the sensible world gestures towards a God of providence and infinite kindness. But it creates a 'spiritual', or let us say *daoic*, work in not allowing the mountain to be confined in any 'form', a definitive, always narrow and mean, form, a fixed form, that is riveted to its qualities. On the contrary, the 'mountain' extends itself and animates itself between these poles that generate intensity and which the trace of the brush links as it continually modifies; decanted from the opacity and materiality of things by its variance, it effectively allows its mass to release a dimension of 'spirit'.

The mountain is 'spiritual', it needs to be repeated, because contrary to the variety which juxtaposes difference along which the charmed gaze saunters, the variance from which it has sprung, in withdrawing the

alternative between contraries, disengages us from the exclusions and rigidities of the concrete. What then is the 'spirit', at least according to its Chinese conception, if it is not precisely what in their foundation gives rise to 'communication', freeing all the opposed aspects from their exclusivity and, consequently, from their opacity? As evidence once more, there is what we are told about perspective—instead of involving the construction of the whole of vision which takes a unique centre as the starting point (the summit of the visual pyramid, as Alberti wanted), from which the geometrical determination then flows as much from the vanishing point as from the line of the earth and the line of the horizon, Guo Xi tells us that it is necessary to combine these three perspectives which complete one another. The mountain *simultaneously* has 'three distances': from the foot of the mountain to raise the gaze towards its summit, such is the 'high distance'; from in front of the mountain to examine behind it, such is the 'deep distance'; or from nearby mountains to contemplate the distant mountains, such is the 'level distance'. If one of these dimensions is lacking, the mountain will be either 'superficial' or 'near' or 'low' (1960: 23). Not only will it no longer be more than a partial vision but also it will no longer be in a position at once, as it is described to us, to 'come'

towards us—'from the front'—in displaying its land-scape in a way that one would never tire of examining, but equally of 'going away'—of 'obliqueness'—in linking up and dispersing itself into the vaporous distance that opens out onto immensity (ibid.). Between the near and the distant which aspirates it according to these poles of the appearance and dis-appearance, and taken in this double movement that conjoins 'coming' and 'going', advance and retreat, it devolves upon the landscape at once to arise and to fade—not to allow its differences to result in forms of Being, so much more beautiful in being deter-mined, but from them to exchange and to animate itself in an intense way.

XII

ESSENCE/VALENCY

Admittedly, to 'be' is also an *intensive*. What justifies the beautiful, in respect of all Chinese animation, is that it makes 'being' more. Variety distracts the gaze and even amazes it, but it is unable to satisfy its vocation. Its legitimate basis is that the more beautiful it is, the more 'being' it has. When it grows old, when its membranes are let go, its flesh slackens and the skin falls, a body has already started to withdraw from Being—toppling over into lesser being—without it even noticing. A chest, in contrast, has more *being* owing to the tightness of its lines, neither too full nor too hollow, and because some are rendered distinct from others as they relate to one another. Under the painter's pencil or charcoal, the curve which finally springs forth and at which he stops—at once deferring

all other attempted traces in an inconsistency by approximation—suddenly fully makes 'being': it *fills up*, literally as well as figuratively. In the same way, when we return to the country at the end of May, whether we cut the grass, prune the clumps of plants, redesign the perspectives or uncover the sections of things from underneath all the vegetation in which they are buried—the better the forms appear and stand out, the more they *exist*. Plotinus offered this conjunction of Being and the Beautiful in an equation: 'abandoned of Beauty, Beauty loses something of its essence' (*Enneads*: V, 8, 9).

For there is a reciprocal dependency between the two: 'Beauty without Being could not be, nor Being voided of Beauty' (ibid.). Each is affirmed only in proportion to the other. We are therefore not deceived about it—the beautiful is really being taken to its plenitude, not an attribute which would be added to it. Each aspires towards the other: 'Being is the object of an impassioned (*pothos*) desire because it is identical with the beautiful' and the beautiful itself is the 'source of *erôs*, *erasmion*, because it is being.' The Greeks produced from this the powerful thought which nothing has been able to abrade: 'to exist' is nothing other than to be beautiful; and to be beautiful is quite simply to exist. Exceptionally, in 'beautiful being',

being by predication and absolute being (the 'being' of existence) are confounded, and the Greeks drew divine jubilation from this—in rising to the beautiful I make being and finally 'touch' (a Platonic word: *aptein*) the imputrescible. Or, rather, a verification *a contrario*—artificial beauty corresponds to false being.

We already know what identifies them with each other—*form* (*eidos*). Because it is form which makes being by bringing it out from matter, which is only support and power, from the inconsistency of the formless, and conferring upon it identity or quiddity: to exist is 'to be with form', *esse cum forma*, such is the basic proposition which comes to us from the very foundation of Aristotelianism and on which classical ontology has been based. The more determined (formed) it is, the more it exists (Hegel again). At the same time, it is the form which renders beautiful in drawing an outline that limits the fluency of things, rendering it 'distinct' and exposing it to perception—*formosus* (*speciosus*) expressing them both in Latin. Augustine only confirmed Plotinus in this respect: 'If it is not what constitutes the mass of a body but what constitutes its form that makes it a body (a conception that is accepted on fairly irrefutable grounds, then a body '*is*', to a greater extent, the more handsome

and beautiful it is, in a less degree the more ugly and detestable it is' (*De immortalitate animae*: 8, 13).

This is precisely what Chinese painters, opening onto a completely different path, turn away from when they paint the landscape, as we are told, 'emergent-immersing', between a 'there is' and 'there is not'—when they shroud forms in trails of mist which widens them as it fades them. Apropos of the painting of Dong Yuan, which Mi Fu tells us is superior to all other, 'the summits of mountains appear and disappear' (*chu-mo*), 'the clouds and mists lighten and darken' (*xian-hui*); the shores and islands are 'veiled and iridescent' (*yan-ying*—Mi Fu 2000: 130; see also Vandier-Nicolas translation in Mi Fu 1964: 36). Or of another painting: 'the structure of mountains is withdrawn and manifest, the summit of trees appears and is buried . . . ' (Mi Fu 2000: 140; see also Vandier-Nicolas translation in Mi Fu 1964: 49). Far from being one element of the landscape, the *mist* is the medium through which forms free themselves from their circumscription and gain in 'spiritual coloration'. Contrary to it being considered that the more forms that emerge, the more beautiful they would be and the more they would exist, it is the alternation of shadow and light, between the poles of differentiation and indifferentiation, or what projects and what

absorbs, which reveals the world in its plenitude. Things open themselves to the dimension of 'spirit' not in the world's visual 'distinction', which is what constitutes beauty according to Augustine, but in its dynamic interaction; not as what emerges most visibly (the *ekphanestaton* by which Plato defined the beautiful), but as the transition by which, evolving between the visible and the invisible, they begin to escape the narrowness of their forms and pour forth.

The Chinese painter therefore paints not 'forms of being' but 'trans-formations'; he is not interested in rendering the essence of the thing, even if this is only a cup or plate on the table (from Chardin to Cézanne and Morandi). He does not respond to the great 'what' of knowledge (that of 'what is it?' or quiddity), but to the release of the animating tension that holds anything to life, including what is most massive, including the rocks, through the cheerful movement of his brush. He brings it out of its reification; a bad painter leaves it inert but a good painter renders it in an alert way—renders it in the capacity of energy which actualizes it. This could be said in another way—he makes it 'subtle', decanting it of its opacity (*jing*, 精). It is in this way, I believe, that this difficult formula by which Shitao defined how painting could be read, difficult not in its Chinese terms but owing

to the way it forces us to unmake our categories. To render it literally: 'This is why there results [from] painting that fine–subtle penetrates the unfathomable' (Chapter 15). As we seek equivalents when translating, let us be careful not immediately to fall back again into our usual representations (as, for example, does Ryckmans): 'In these conditions, the painting will be able to penetrate the essence of things to the point of what is imponderable' (Shitao 1984: 111). No, there is no 'essence' in the philosophical (ontological) sense, that of knowledge exploring the character of things in their invariant and constitutive features—'penetrating' the secrets of nature, according to the old Western dream inherited by the painter. Or if 'essence' there is, it is in a totally difference sense, that of precisely those alchemical procedures that the science of nature has obscured and caused us to forget (but which are indeed raised by these terms in Chinese, *jing* and *wei*)—that of acceding, through the evolving line of the brush as the ink diffuses in a halo, to the more subtle state, made quintessential and more energetic, thus opening out onto 'unfathomable' transformations.

What does the Chinese painter have in mind when he traces mountains or water, trees or people? Shitao intimates it through these parallel formulations:

*In painting as regards the mountain,
spirituality is conferred;
In painting as regards water, movement is
conferred;
In painting as regards trees, life is conferred;
In painting as regards men, surpassing is
conveyed* (1984: Chapter 7).

Whether it is the mountain or water, trees or people, the components of the landscape are painted not in order to penetrate their nature, by referring to an essence, but for the ways in which they each correlatively have value and so bring out the various dimensions of a landscape: 'spirit', 'movement', 'life' (of 'growth'), 'surpassing' (a way of rendering *yi*, 'eminent', 'comfortable': the human element adds a touch of singularity and free animation). *Valency* is how I would call this means by which each of these components engages a typified liaison with the others and promotes its value in relation to them. Let us note that Shitao does not here speak of painting the mountain or the water, but to paint 'as regards the mountain' or 'as regards the water' (*yu shan, yu shui*). The 'mountain' is not an object but a resource; rather than even being a theme, it opens a rubric of effects to be developed— from one or the other, the painter *releases* (I will come back to this term) the capacity.

The essence appears *through difference*—on this point the Greeks barely hesitated: difference is what allows us to distinguish and take account of it through reason (Plato, *Theaetetus*: 201a); or, more precisely, that by descending from difference to difference to the point of 'ultimate difference', the individual being of each thing, its *ousia* (Aristotle, *Metaphysics*: Héta, 2) can be grasped, because it is through progressive differences that this being emerges from the indifference of matter, passing from what is only potential to what is enacted, and so acquires its quiddity. 'Form', in other words, is constituted only from differences. Otherwise, to place in doubt the being of difference, as the Sceptics did, to establish everything on the basis of equality, *ex isou*, means no longer being able to prefer or proffer anything and everything being confused— 'man' could equally well be 'trireme', a 'god' or a 'rampart', mocked Aristotle, and life would become unliveable, condemned as one would be to deny oneself at every step. Chinese thought does not deny differences, nor is it attached to them and nor does it reify them; it invites one to go back beneath the differences to their *undifferentiated ground* in which they 'communicate' (the *tao* of *Chuang tzu*), from which they proceed but which at the same time abolishes them. Difference, in other words, is really effective,

and not apparent, at the same time as it allows a glimpse its re-absorption. Equally, Chinese thought neither reinforces difference nor banishes it. Nor does it fix it as an entity or deprive it of its pungency—it does not inscribe it in Being but arranges it 'at will'.

The Chinese painter verifies this through his practice: 'When clouds are painted, they cannot resemble water and, when water is painted, it cannot resemble clouds' (Fang Xun 1962: 57). There is a strong difference between the two and, even though it is subtle, the apprentice who sets to work cannot allow himself to neglect this principle. 'Yet, once this principle is well assimilated,' our critic continues, 'one will cease to wonder whether [it is] clouds or water: when the brush is applied, if the intentionality [the 'internal incitation': *yi*] regards [it as a] cloud, then [it is a] cloud, and if it regards [it as] water, then [it is] water.' Difference has no essential status, but remains available—there is specificity of aspect, which by its individuation forms what is sensible, but without it being isolated or compartmentalized. Staying attached to difference, in contrast, would prevent our receptivity from circulating prior to what, in distinguishing, is fatally reinforced by perception when it identifies.

For Shitao also says (1984: Chapter 18) that it is in returning to this 'receptive' (*shou*) capacity that the

painter functions effectively—a receptivity more orig-
inating than what, in becoming distinct, brings forth
beauty. In this state, he does not simply deploy the
valency of the various components of the landscape,
of the mountain or the water, but apprehends their
equivalences. Thus the *mountain* is very different form
the *sea*, but there is an exchange and communication
between them: 'the sea engulfs and vomits, the moun-
tain slopes and rises' (as if in welcome). They meet
through their rhythmic alternation. The mountain
(with 'the succession of its summits and the linking
of its cliffs', 'its valleys which are hollowed into gorges
and its deep ravines' and so on) is like or, rather, *is
equal to*, 'the unfurling of the sea in immense waves,
at once engulfing and vomiting'—this is not 'a soul
which the sea manifests' and yet 'the mountain can
then be superimposed with the sea' and confirm its
capacities. In the same way, the sea can 'superimpose
itself on the mountain' and effectively transpose its
features—thus in going from 'the immensity of its
waves and the breadth they contain', 'from its wild
laughter, its mirages, its whales which caper and
its dragons which rise up', and as far as 'its waves
which rise like peaks, its tides like summits'. If this
apprehension is attained only from the perspective
of one or the other, of the sea or the mountain, each

in an exclusive way, this 'would be detrimental to receptivity'.

'For myself, I know how to be receptive to both,' Shitao proudly announces, in such a way that 'the mountain is equivalent (*ji*) to the sea and the sea to the mountain'. Apprehending them in their fundamental equivalence, prior to their fixed perception, I render the Mountain metaphorical for the Sea and the Sea for the Mountain (Péguy notes: 'and the powerful swell and the ocean of wheat'—one element apprehending itself through the other). The metaphor does not deny difference (by a denial of the objective) but it *makes it pass through us*, leading towards a more originating state (before 'objectivity'). Equally, Shitao did not say: 'the Mountain is the Sea and the Sea is the Mountain', as Ryckmans translates it (1984: 100) because this would be to misapprehend all the differences between them. Still less (following this): 'Mountain and Sea know the truth of my perception' (in which in Chinese *er* [for this type of construction see Confucius, *Analects*: VII, 2, *mo er shi zhi*] is not translated and this causes it to fall back into European categories). But 'it is on this sea-mountain mode' (in other words, the equivalence between Sea and Mountain) 'that I know, such is my receptivity'— that which the painting evokes so as to render the

animation of the world and not to explore Being and, by means of the beautiful, lead to greater being.

RESEMBLANCE/RESONANCE

When it is not the beauty of natural objects, born from variety, beauty is resemblance, at least in its classical conception. For Hutcheson once more (or Diderot), it is that of imitation—*relative beauty*. The work is beautiful to the extent of being in conformity, even in unity, with the model of which it is the image, and then only through what this naturally mimetic activity of man adds or promotes. To remark on this is a commonplace—a reproduction is beautiful owing to its exactitude, even if the original is ugly. The face of an old man or some arid mountains, hideous animals or corpses, are beautiful because they are 'portrayed well'. *Mimesis* indeed isolates a truth, as Aristotle taught—in dissociating the 'proper form' of the material from what it is associated with in nature

(what the Greek names precisely *apeikazein*), the painter places in evidence the formal cause of the object and raises it from the particular to the general— he makes work from abstraction and knowledge. Through this simple transfer of form, levied as it is from the natural object to be transferred onto the artist's base, it emphasizes an essence at the same time as it arouses a pleasure of recognition—faced with such a successful imitation, I am at once 'amazed' to find the original in the copy and 'I learn' how better to appreciate 'what' it is. Once more it is the Greek question of 'what is it?' or of 'quiddity'.

In the Greek context, this conception of man's mimetic activity had to be developed owing to the fact that it is found to be measured by a very much more general option which is nothing less than that (once more) of metaphysics. If we have seen him detaching himself from Plato in considering that the arts are not content to imitate natural objects but that they 'go back' to the reasons from which they are issued, thereby remedying the defects of things, Plotinus no less understood that the beauties of this world are tarnished images—traces or shadows (*eidola*)—pure beauties from 'Over There' (*Enneads*: V, 8, 8). The relation of *resemblance* serves in this way to compensate for the *separation* of (sensible/intelligible) levels

that will have redoubled by its reflection, in an admittedly reduced way, what the latter had divided in two. In the West, the 'image' (*eikôn*) is therefore pinned ontologically to the idea of a doubling, its destiny being from that point to maintain the rivalry between the two—the model and the copy. Was there a loss of Being, from the former to the latter, or on the contrary a gain of essence? Hence this question is presented to us with respect to Chinese tradition: How, and to what extent, can the conception of painting as reproduction, which has dominated our classical Age, be developed there? Let us properly understand this 'to what extent'—it examines the basis on which, if it is not ontological, this conception could gain a foothold in China and develop like that of an afferent beauty by imitation. If not, since we know that in China the world is considered not in terms of Being but of breath-energy, what other conception has been able to prosper there which would form a counterpoint—screen—to that renowned 'resemblance' put forward as the criteria of beauty, at least according to the facile judgement of critics? Have painters in Europe themselves ever truly believed in it?

A very fine collection of *Notes on the Art of the Paintbrush* (*Bifaji* by Jing Hao, in the tenth century) shows precisely what the 'to what extent' entails.

Interrupting the dialogue, a neophyte in painting considers, in a satisfied way, that 'in order to attain truth it is enough to enhance the resemblance': 'What therefore should we be disturbed about?' (Jing Huo 1960: 7) The old Master replied that it was necessary to know how to distinguish between the 'blossoming', or the external manifestation, and the 'fruit' (*hua/shi*). Without this, one could obtain a certain resemblance but not manage to 'represent the true' (*tu zhen*), because 'resemblance' attains the form of things only by abandoning the breath-energy which is actualized in them. What creates the 'truth' (authenticity) of painting, in contrast, is that the 'materiality' and 'energy' which animates it should both be carried to their culminating point. For when the breath-energy is transmitted into the external manifestation, but is abandoned at the level of the phenomenon of the image then, the old Master warns, it means 'the death of the image'. Not only is the resemblance just one of surface but especially, he reminds us, the 'image' is at the same time a *phenomenon*—the term is the same in Chinese (*xiang*, 象). It is consequently not understood as coming to double the natural world but can 'die' like any other phenomenon of nature—when it loses the breath-energy which passes through it and maintains its life.

In this way, Chinese reflections about painting are led to oppose the idea of resemblance justifying beauty with an appropriate quality of breath-energy (*qi*) that generates the life of beings and things—this it calls internal 'resonance' (*yùn*, 韻, derived from *yin*, 音, 'sound'; this can be better translated if we think of Kandinsky who said that it must be attained 'by the internal resonance of the form'). Between *resonance* and *resemblance*, in the way that the two reveal themselves in parallel in English as well as in French by the *re-* of the echo or the duplication, the divergence is rooted in alternation: one is a prolonged representation of internal timbre, the other a specified reproduction of external features; the first is rooted in innumerable vibrations, the other will soon run dry on the surface; one is deployed of itself in a phenomenal process, the other remains limited to the concerted 'to do' and is governed by its aim. Emergence through 'energy-resonance' (*qi-yùn*, 气韻) has been made the first principle of painting in China, not only above but apart from all others, as something that cannot be obtained by skill or application—'energy-resonance: life [to engender]–movement' (*qi yùn sheng dong*—Xie He, fifth century). All later theoreticians only repeat this canonical formula and vary it, none of them dreaming of bringing it into question: Would

not these four words indeed succeed in expressing the essential, the Talisman about which thereafter it would be possible only to meditate? Hence this judgement passed into a truism: '[Formal] resemblance is easy, the resonance [of the breath-energy] is difficult.'

When it comes to considering *resonance* and *energy* in parallel, resonance was defined in the dialogue between the neophyte and his old Master as being 'to establish forms [actualizations] by drawing from them their traces' (*yin ji li xíng*—Jing Huo 1960: 8). For the art of the painter is certainly an art of representation, but it should not get bogged down in representation; it certainly produces visible forms, but these are of value only as conformations of invisible energy. Hence the established distinction between two types of errors: those which arise from *actualizing* (*you xíng*, 有 形): when the seasons are not respected, proportions are not observed or 'the bridge is not linked to the shore'—clumsiness which is correctable; on the other hand, those which do not arise from actualizing (*wu xíng*), but are produced prior to it, are, as such, irretrievable: when energy and resonance are deficient, the representation of the whole is false and so, no matter what the movement of the brush, the result is 'dead' (ibid.: 8).

What is then called the *trace* is the fossilization of energy (forming a deposit) which renders the form inert and brings 'death' to the painting. It is what has not been decanted, what remains opaque and does not allow the energy from which the dimension of spirit comes to pass through. It is in 'breaking with the trace,' says Mi Fu, that the spirit or natural dynamism rises to 'the summits in the mists and colours the rocks' (Mi Fu 2000: 123–4; see also Vandier-Nicolas translation in Mi Fu 1964: 24). Either, expressed negatively, it is by 'not sticking to the trace' that, even when painting flowers, life and movement can be obtained, or 'the formal traces would have resemblance, but without vital energy' (Fang Xun 1962: 69). The *Shitao* delivers it in this parallel formula—in the originating state of 'receptivity', that of the sea-mountain equivalence, one evolves at the level of that which does not yet have tangible form; then, when one has organized what assumes form under the brush, it is necessary to be 'without traces' (*wu ji*, 无迹). There is then no further resistance or obstruction; the spontaneity of the action engendering the line joins that of the process of the world: 'The ink evolves as though it was already done and the brush is handled without acting' (Li Wancai 1996: Chapter 16).

The resonance will therefore not arise from outside, as resemblance, but from going 'through' (*jiān*,

间 : the double door under which the moon's ray passes); it is not deployed on the surface of the form, or in its outline, but 'between' its various features (Fang Xun 1962: 17). One can hear it in this famous comparison (Su Dongpo): to look at a painting by someone of refinement is like examining a good horse, one must manage to grasp what the internal stimulation and energy achieves. Those who are merely artisans of painting render only the whip, the pelt, the manger and even the fodder, without there being anything of the energy that animates the steed, and one soon becomes weary of it. But it can be deduced from this image, notes a later critic (Fang Xun again, 1962: 26): above all, that what is in play in painting does not in fact consist in these material attributes or elements, like the riding whip or pelt, but also that, if one leaves them aside, 'there is no longer a horse at all'. The consequence is that the impetuous energy that carries the steed along can be found only 'between' all these concrete aspects, which are not reified, including the skin and the riding whip. It is therefore in this overlooked *between* that the resonance, as a vibration of energy, is 'transmitted'.

Exactly the same thing can be said about resonance as has already been said about difference. Chinese painters are no more attached to it than they forgo it. It is neither inscribed within Being nor does

it do without its resources. If to consider a painting from the perspective of resemblance is 'close to childishness', according to a famous formula of Su Dongpo, borrowing from the forms of things is also what nourishes painting. It is reported that when he noticed some old trees or extraordinary rocks during his walks, Huang Gongwang drew from his bag a paintbrush and made a trace of it. 'And yet when we consider the works he has left, we do not see twisted branches or strange rocks in them' (ibid.: 113). The painter is neither stuck to the motif in order to reproduce the form, nor does he scorn what the motif can teach him about the *variance* of form—he examines even in these most unwonted of forms the way in which energy has been able to make its way through the sensible materiality to result in this extreme result, and he enriches his repertory of forms with them. This is what has been called 'looking like without resembling' (*si bu xiao*). This resemblance freed from the compulsion of imitation and remaining available while operating 'at will', I would call *semblance*.

How should the 'truth' in painting with which the dialogue of the Land the neophyte begins be understood? Not as truth through adequacy of form, nor by deconstruction and reconstruction of the perceptive object, as will later be done in European painting—

but through visual *decanting*. Guo Xi tells us: let someone who wants to learn to paint bamboo take a bamboo shoot and, one moonlit night, meditate on it reflected against a white wall—'then the true form of the bamboo will appear' (1960: 19). The same thing applies at a broader level—by contemplating the gorges of a 'true landscape' from afar one attains 'depth'; by walking in their proximity, one attains 'superficiality'. The two complete one another—rendering the landscape anew as in *multi-resolution*, they release from it the atmosphere which crosses through it. Or, by contemplating the cliffs of a true landscape from afar, one attains their 'animating tension'; considering them up close, one attains their 'materiality'; and the two act as a pair to engender their 'truth' (ibid.). From coordinating both levels, just as it combines all perspectives within it, this landscape is not allowed to instigate a rupture from which the operation of the painting could come to *double* the world (everything even seems done in these treatises of painting to thwart such a mimetic relation). It will therefore draw out its truth, not from the work of representation but from its capacity of *impregnation*—we 'bathe' in this landscape. As Guo Xi said earlier: 'Obtain a marvellously endowed hand and everything springs up in profusion: without going down from the

hall or leaving our matting, one can, while sitting down, explore the springs and ravines; the voices of monkeys and the cries of birds are still dimly heard in one's ears . . . ' (ibid.: 17) Of this landscape, the 'truth' is the environment, if this term is not too weak—or then it is now for us to support it. It is of the order of the diffuse and the unassignable, or I will say of 'pregnancy'.

XIV

PRESENCE/PREGNANCY

From the fact that, from beautiful, he has produced the beautiful, the Greek can say, believing he is only developing what language logically says, that things are 'beautiful' *through* the 'beautiful' (at the beginning of the *Greater Hippias* which is also the beginning of philosophy). Then, going a step further and elevating the entity into a separate essence, which is the decisive step he crossed (in the mature works, *Gorgias*: 497e; and *Phaedo*), Plato was able to clarify the nature of this 'through'—things are beautiful through the 'presence', *parousia*, of beauty. The beautiful henceforth having a separate existence it is, in return, as it renders itself 'close to' beings and things, in being 'present' to them (*prae-esse*, the Latin also says) that they are rendered beautiful. In them, admittedly, but

without this inherence for all that being confused with them and causing it to lose its own nature—temporarily entering their field of designation (this temporal being the very one that defines the 'present'), from where the possibility of 'participation' and 'communion' results, but coming from an elsewhere and being able to absent itself. All presence is understood on the basis of absence. So let us therefore no longer look for the why of the beautiful in colour and outline, *chrôma-schema*, according to the two rival theories, but concern ourselves, as Socrates demands, with the only internal explanation that nothing will consequently be able to contradict in its generality: 'The beauty of this thing is produced by nothing other than by the presence of the beautiful' (*Phaedo*: 100 c–e). As a result, all bets are already off: Western philosophy will be a philosophy of *presence* born from its metaphysical doubling, in other words, from coming here, close, in proximity, from what is ontologically separated. Because, by crossing this step and following it to the limit, elevating the beautiful to an absolute, 'presence' is sacralized—the beautiful then becomes a revelation or *parousia* of the Beautiful, causing the Pure (Being, the Eternal) to spring up suddenly in 'proximity' to the sensible.

In *Phaedo*, Socrates is amazed (affects amazement?) at the very simple and elementary character, obviate and therefore hardly contestable, of the proposed solution. As though one returned from it to the platitude of a truism, that so little was peeled away from the tautology: things are beautiful owing to the presence of the beautiful—what could be simpler? But is it so simple? As though this explanation was simply a clarification, and that these terms which appear closest to illuminating the immediate ('presence' or 'present') to the point that one no longer really has control over them to comment on them, has succeeded in concealing so well, in a definitive way, how much distance they assume taken in respect of this immediate and dramatic rupture. Once again, it is the beautiful which serves as a privileged testing ground for the operation of a burying of the metaphysic, consecutive to the Separation. How can the degree to which this 'presence' of the beautiful is no less conceived as an intrusion that does violence to the phenomenality of things be forgotten? Plotinus at least was not afraid to assert the fact. What is this 'present of the body' (*to paron tois sômasi*—*Enneads*: I, 6, 3) which renders them 'beautiful'? It is, let us repeat, that of an 'incorporeal light', which is Form and reason born from elsewhere, as is well known, and

coming to dominate the 'darkness' of matter, insofar as it really wanted to give way to it.

We are therefore amazed in our turn by this non-amazement—that ordinary language, in Europe, could have assimilated this violent action of thought, of which the 'beautiful' is the object, to such an extent and without flinching. And this to the point that we would all be able to say so banally, as though one saw nothing implied in it, no pledged option, and as Diderot still did as well as others: the beautiful can be only 'what the presence of the beautiful renders beautiful' (1951: 1096). What did Diderot nevertheless not do to escape the folds of metaphysics? I *cannot imagine* such a phrase being written in classical Chinese. To this option of *presence*, hiding the abyssal distance under the intimacy of proximity, or working to restore what it had first of all taken out, which effectively made it into the dialectical category of metaphysics, it is time to oppose what I have just termed 'pregnancy'. *Pregnancy* is that modality which does not isolate but which passes through, 'transpires', 'transmits'. It is of the order of the 'between', like the resonance—and lets emanate by means of decanting; which does not focus but disperses, which does not immobilize but allows to communicate, and above all, literally, which is swollen with (pregnant with), which

therefore obstructs the great antinomy of presence and absence (from which the tragic is born), consequently distrusting clarity and the definite (in which respect it is rebellious towards the idea) and does not let dis-cern. Consequently, it is against the *distinct* character which makes beauty.

In relation to the painting of Shen Zhou: 'Return in a boat in the wind and rain.' But it would be better to keep to what is literally said, not succumbing to syntax and construction: 'Wind—rain—return—boat' (*fēng yu gui zhou*): 'His brushwork is free and careless; welcoming the wind, he [has] made numerous willow branches [under] the rain; further on a sandbank; and [then] a solitary boat, [with] a garment and straw hat, as though this was found in the midst of waves.' Someone, pointing with their finger, asked me, 'But where, then, is the rain?' I replied: 'The rain is where it is painted and also where it is not' (Fang Xun 1962: 121). The rain is nowhere isolatable and is everywhere. The *un-painted* is not an invisible metaphysic, of the order of the unrepresentable, because this is really a question of what is phenomenal—the rain. But rain cannot be confined and made perceptible in isolation—it is diffused and disseminated between 'there is' and 'there is not'. That the art of the brush might here be said to be 'free and careless'

('unconstrained') signifies this refusal of the assignable, circumscribing each thing in its place and its own being—the rain *impregnates* this landscape.

The Chinese language is rich in precious formulations which express the ambiance, or pregnancy, as when one paints a landscape in the rain or, rather, which ponders on this indiscernible by composing pairs, since a single isolating notion would always be at a loss to account for it. For example, by combining the notion of image-phenomenon (*xiang*, 象) with that of breath-energy, thereby clarifying how the different orders of the figurative and the tangible can be spread in an impalpable and yet uncircumscribed way. This 'breath-representation' (*qi-xiang*) conjoins in a single thought the invisible energy unfolding to infinity and the sensible manifestation which actualizes it—the word 'atmosphere', which corresponds most closely to it in European terms, is so inadequate. . . . The (faulty) contrary would be to 'attach oneself' and to 'stick' to the representation (*zhù xiang*, 著象). Landscape painting, it is said (Tang Zhiqi in Guo Xi 1960: 108), is not something one should apply oneself to in a constrained way. This shrivels up and contracts the line and, because of this, paralyses it. When the great painters of the past filled the whole surface of the wall with scattered islets and shores, or painted between

'there is' and 'there is not', or if in their paintings the mists rise up in profusion from the mountains, they are not 'attached' to the figurative aspect of the representation and their painting does not sink into these *traces*. Or that when people are painted, it is appropriate to 'transmit their spirit' or that, when it comes to flowers and birds, it is appropriate to 'trace their life'; one paints a landscape while 'retaining its shadow' (*liu ying*), and not its tangible form. Just as, in the same way, when one learns to paint a bamboo, one already takes into account its reflection on the wall on a moonlit night

Another compound term to reveal (to think through) this expansiveness is 'wind(s) and wave(s)' *fēng-liú*, 风流. Because a landscape is to be envisaged not only in its structure of tension by polarity ('mountain/water[s]'), but equally by what flows through it and, maintaining circulation within it, prevents it from sinking into limitation and inertia. It is when we apprehend the landscape on the mode of the equivalence of sea-mountain, said Shitao, and therefore as prior to the assignative, that such pregnancy appears at each stroke of the brush, as in each eruption of the ink (Chapter 13). Such a conjunction just as much takes hold of poetic pregnancy:

Do not be attached to one word alone :
Attain winds and waves in their completeness

(Sikong Tu, 'Han xu' in the *Shi Pin*).

Not to 'stick', or 'adhere' (*zhù*), to a single word, not to confine oneself within a single meaning but to release into its plenitude what, in principle, is too diffuse-disseminated to be graspable by name. No longer will one render the aspect that is defined, and in consequence marked out as particular to the thing, as an isolatable 'this', but that which (but this is no longer a 'that which') the bias of ontology will never allow us to say except in an impoverished way—not the quality or property of an in-itself, which encloses the thing in its difference (and justifies it in essence), but what, 'contained' and 'hidden' (*han-xu*), leaves the reference evasive and renders what is implicit inexhaustible. It is spread indefinitely from the 'resonance' rather than in response to beauty, which circumscribes owing to its form and is rendered more prominent to the gaze—such as is incarnated by the Nude.

XV

ABOUT THE NUDE OR BEAUTY

It was within the Nude that the Greeks conceived of beauty. Between the desire of the flesh and the modesty of nudity (and practically neutralizing them both), the Nude (in art) isolates this separate level on which the Beautiful is perched. For the Nude is not one being among others and caught within the indefinite texture which forms the world, but is detached from it and becomes the location of an operation that is in truth unique. It has ceased to be this body in movement (or even at rest) whose sequences (or even just its quiverings) could be filmed, and has become the body *stopped* and given a pose by painting or photography—there can be no Nude in the 'cinema' but only denuded bodies. It is consequently no longer that temporary conjunction of fleeting lines ceaselessly

being renewed but its purged outline, among all the possibilities attempted, whose perfection renders definitive. If it assumes the intimacy of an individual, it is, with all personality being effaced, to make it serve as an objective support of the forms to be worked. It really occurs closest at hand, in the immediacy of the sensible, at the same time as it is the privileged terrain of modelling, inverting what is sensible from being of the flesh into a Form that might be ideal. A Nude is not empirical. In it, lack is suddenly changed into completeness, denuding into unveiling. One art after the other—sculpture, painting, photography—has endlessly returned to it in a stubborn way, always to explore again new paths of beauty freshly, in a focussed way, and without even modernity having been able to uproot it. The West has learnt the beautiful by practising the Nude. We understand at the same moment why China, which nevertheless developed figurative painting and sculpture so widely, has passed over the Nude (see Jullien 2000).

In fact, all the preceding divergences are verified in relation to the Nude:

(1) In the studios, the poses of the model are made to *vary*, indeed to be held still longer, with the aid of a machinery of straps and ropes; (2) the Nude de-individualizes and de-historicizes; it abstracts an

essence. In the same way that Cartesian physics 'divests' the block of wax of its secondary characteristics in bringing it close to the fire so as to consider it 'naked'— *tanquam nudam considero,* as Descartes said—as *res extensa,* the Nude withdraws the secondary features, those of the epoch or the condition, to respond to the 'what is a man?' taken in its generality. If mythology privileges the Nude, it is because it allows it to express virtues or entities more effectively (if Canova sculpted Napoleon naked, it was because he incarnated the genius of war; or his sister, rep-resented naked with an apple in her hand, is *Venus victrix*; a 'person' [an interiority] could only be represented clothed); (3) the Nude is required to have a *resemblance* (oh, how rig- orous!) to the morphology of the human body and painters, like sculptors, are obsessed with anatomy— all 'internal resonance', on the other hand, immedi- ately finds itself to have dried up; (4) finally, the Nude focuses *presence*, even forces an entry. As evidence, take the rustic landscape or the carpet in the bed- room: they do not touch the Nude and are only a frame for it. The Nude is extracted from 'all ambiance'. In removing the intimate, the Nude exposes; through this appearance that in the end reveals everything, it breaks the framework of things and makes an event, and even when its outlines are blurred or decomposed

('in the bath'— Bonnard, or 'descending a staircase'—
Duchamp), a Nude is never 'pregnant'. It would be
wrong to believe that a Nude integrates the body into
nature or, as they say, 'naturalizes' it. On the contrary,
it increases the separation that is introduced into it
by the clothed and isolates it even more—humans
alone are (can be) naked.

At the beginning of *Critias*, Plato already hinted
at this exception of the Nude. Landscape making a
sudden—and very rare—appearance in his dialogues,
he drew an argument from the fact that we are con-
tent that painters vaguely imitate 'the land, the moun-
tains, the rivers, the forests and the sky in its totality'
because they are the object of no precise knowledge,
while when it comes to the human body, which we
know best of all, the exigency is completely different.
The same reasoning moreover is to be found *mutatis
mutandis* as a starting point in China—it is more dif-
ficult to paint 'horses and dogs', which everyone sees
every day, than 'spirits and ghosts' which no one has
ever seen (see Han Fei in Yu Jianhua 1996: 4). In the
Chinese context, however, it will be noted that it is
no longer the human body which serves as the exem-
plification of the visible. When it is made part of it,
the value judgement will be led into reverse. It is even
amazing to see how the formulations of Chinese

theorists precisely confirm those of Plato—the matter of experience of course can only be the same—but all the better to branch off (Su Donpo, eleventh century, in ibid.: 47): 'Whether it is a matter of people, animals, palace or even utensils, all have a constant form', thus the slightest error in their respect will immediately be noticed. In contrast, as far as 'mountains, rocks, bamboo trees, shadows, waves or mists' are concerned, there is no constant form within them and it is only their 'internal coherence' that is 'constant' (*chang li*, 常理). Human representation is poor, in other words, because of imposing its form (note, moreover, that people are still not placed apart in this list of the uni-form); while the mountains, rocks, trees, mists, and even the bamboo do not impose form—they take on and make available every possible form (such is their *variance*) and thus it is the 'coherence' of energy that configures them in so many diverse ways that it is necessary to grasp with one's brush. This is also why painting, in China, will so much sooner come to abandon personages and fixed forms, in favour of landscapes, which leave us with the initiative of form (Guo Ruoxu in ibid.: 61).

It is true that Plato, for his part, was far from seeing in the Nude the sole object of a meticulous observation—the artist refines this curvature of the

body as a 'paradigm'; from this mass of flesh he draws
the form of a being as it should be. The Nude has
detached the human body from the sensible world
and explores (and promotes) through it an intelligi-
bility which one can no longer submit to the testi-
mony of an experience. In this, it is really the terrain
of elaboration and modelling of the beautiful. It is a
theoretic work, not a realism or naturalism, which jus-
tifies the invention of the Nude. 'Do you think,' asks
Socrates of Glaucon, 'that he would be any the less a
good painter, who, after portraying a pattern of the
ideally beautiful man and omitting no touch required
for the perfection of the picture, should not be able
to prove that it is actually possible for such a man to
exist?' (Plato, *The Republic*, 472d–e). It has, we know,
notably been with the tools of geometry that the
artists have approached the Nude, transferring onto it
the Pythagorean idea that 'everything is number':
all beauty is founded on an arithmetical-musical
structure which the 'studies' of the Nude aim to
recover—the beautiful, as Aristotle himself said, even
though there was little Pythagorean about him, is the
principal object of mathematical reasoning and its
demonstrations (*Metaphysics*: Mu, Chapter 3). This
harmo- nious beauty which delivers the Nude cannot
therefore be reduced to the anatomical regularity

perceived by the eye, but it is assimilable to the perfection of an accord or a consonance whose principle is a relation of numerical 'equality', *aequalitas*, as Augustine said, uniting the whole of this disparity and rendering it commensurable—it will result in the vitruvian representation of Man inscribed at once in a circle and a square and elevated into a symbol of mathematical sympathy linking all worlds between them.

If the Nude is the support of the beautiful, or if the beautiful is promoted from it, it is therefore because it best assures the function of *mediation* which falls to the latter, as we notice once again: arising at the heart of the visible and even rendering as visible as possible (*ekphanestaton*) the interpenetration of the sensible and the intelligible, which are otherwise considered as dramatically separated—and even when it comes to what matters most, or most vitally, to humanity, in other words, itself. The Nude is the great reconciler of a torn humanity—this, I believe, is what constitutes its true function. Indeed, the Nude will incarnate beauty all the better for succeeding in conjugating within itself the two rival options that the Greeks have developed from it: that of the beautiful through the triumph of unitary and modelling Form (Plato to Plotinus), and that of the beautiful resulting from the proportion and agreement of all of the parts

(in the Stoic tradition). What is the Nude, in truth, if not the motion of synthesis that can be proposed of the beautiful?

To draw or to sculpt a Nude is really, first of all, to 'mould in conformity with the 'form-idea' (*morphousthai kata to eidos*, as Plotinus says in the *Enneades*: I, 6, 2), the one which the spirit perceives in itself at the end of its theoretical elaborations—this form does not simply manage to 'envelop' the fluent mass of matter by means of its limit but also to confer *distinctio* upon it, to take up Augustine's term, separating it most clearly from what surrounds it (which is no longer more than its decor) and causing it to stand out. In this way the fact that a Nude hoists the human body up from the undefined and the perishable and causes it to attain Being is so much more moving in that its flesh, which nothing any longer conceals, is what is most fragile, its flesh colouring what is most tender and delicate. In considering the great Nudes, I believe that this is really what they realize. Completely unveiling the human body, at the same time they tear away the unbroken tissue (that becomes a curtain) of phenomena in order finally to 'reveal' what lies beneath; breaking with the diffuse of the rhapsody of the senses, they isolate a proper and definitive being. They suddenly cause an *everything is*

there to emerge from presence. *Everything* is finally visible. From the very heart of the sensible world, they draw an absolute to which nothing further is lacking, which leaves nothing more to be desired, and in which man discovers his own image in amazement. Faced with a great Nude (Botticelli, Leonardo, Poussin . . .), we have this unique experience in which it is ourselves which appear as objects of Revelation or *parousia*. As a comment on the great Nudes, the ecstatic language of Plotinus is not excessive. To contemplate a great Nude is always to enter into metaphysics.

On the other hand, from the Stoic side, the Nude responds to this essential question of ontology: What strange 'being' is a 'part'? It is at once one and not one—one since it can be distinguished, but not one since it does not itself exist except when linked to others on which it depends. The organs of the body are individually beautiful at the same time as they no longer have beauty if they are abstracted from their organic articulation: between one finger and another, then between all of the fingers and the metacarpal, then the carpus and so on (Polyclete's *Canon*). A part loses its particular value if it is isolated in part—a beautiful hand which, when considered alone, was praised as part of the body, loses all its grace when separated from it (Augustine 1991: 80). The work of

the Nude therefore shapes these two complementary modes of beauty: both the beautiful by itself (*pulchrum*), and the beautiful through adaptation (*aptum*); hence it involves these two conjoined operations upon which European reason since the Greeks has been constructed—to decompose into constitutive elements and to recompose into something totally unique. 'Analysis' and 'synthesis' (*diairesis* and *sunagôge* in Plato; *discernere* and *conectere* in Augustine). At the same time, I 'discern' each of the organs, and down to the slightest element of the body, in order to enhance its own being and I 'link' it to the others in order to enhance the integrity of the whole. The Nude is this exercise.

Whoever draws the Nude knows that indeed this is where everything is played out in terms of beauty—that each part of the body is exploitable as an individual resource at the same time as it resolves itself into a unity which makes it forget it. Seneca says: 'A woman is not beautiful when her ankle or arm wins compliments, but when her total appearance diverts admiration from the individual parts of her body' (1968: 79). It is the unity of the parts at the heart of the Whole which is both the principle and the object of beauty, as Augustine ultimately said, thereby reconciling both Plotinus and the Stoics: 'An eyebrow is

virtually nothing compared with the whole body; but shave it off and what an immense loss to his beauty!' (1998: 454). If the Nude is central in art, it is because from it we will experience the slightest defect in completeness most intensely: more than anything else, it makes the beauty of the Whole evident—*pulchritudo in toto*. More than anything else, it implements this double movement of divergent deployment of unity in the exteriority of the multiple at the same time as making a convergent return to the One which is its 'soul' (the continuity of which is verified from Augustine to Hegel (Hegel 1986: 203). The study of the Nude is therefore the logical basis of the teaching of the beautiful in European schools—ever since Vasari, the word 'Academy' expressed both movements.

In China, in contrast, the old manuals prepare us in the handling the ink and the brush using the painting of rocks. While a Nude imposes its definitive form, a rock will take whatever form one likes. It remains to give it a consistency or a 'constancy' of a rock such as to make of it a coherent agglomeration, not an inert form. Let us not forget that rocks are called 'the roots of the clouds' since at the same time it has always been a matter of dealing, from both sides, only with actualizations of energy, more disseminated in one case and more condensed in the other.

Furthermore, no more than a cloud does a rock decompose into its parts (the Chinese have not thought in terms of parts-whole or of analysis and synthesis but of 'emptiness' and 'fullness'), and it will be by alternating the empty and the full in one's line that one will allow the full not to become fixed but, by being emptied out, to allow the vital energy to communicate through and through—even for the mass of the rock, desaturated and no longer opaque, to continue to make evident the process of engendering from which it was born.

Or, when one represents people, it is necessary to be alert and, as the *Arts of Painting* recommends, to respect differences of epoch and conditions in dress (Guo Ruoxu in Yu Jianhua 1996: 450), just as it is necessary to apply oneself to integrating humans into nature—it is advisable that they 'respond' to the landscape and remain in connivance with it; the landscape also 'responds' to them. It is as if man looked at the mountain and that the mountain equally leant down in order to look at him (see 'Renwu' in *Chieh Tzu Yuan Hua Chuan or Mustard Seed Garden Manual of Painting*, Mai-mai Sze 1956) Otherwise the mountain would be reduced to the mountain and man to being a man: Where then would the landscape be? Far from masking the form of the body (let us recall

that in the classical age in Europe, they started drawing nude bodies in order to constitute their morphology more effectively, before clothing them), in the folds and the undulations of the dress and even the ripples of the belt, the clothes will cause the circulation of the internal breath and its rhythmic beat to rise to the surface and appear. Far from constituting itself in a determined Form, what we call the 'body' is also perceived, by the Chinese, to be a receptacle of energy whose lines of enveloping are secondary (this is why they have little interest in anatomy but in contrast pay extreme attention to the internal circuits of vitality). When faces are painted, it is the internal stimulus (*yi*) that must be expressed—the outline can be neglected, but to omit three hairs on the chin or light wrinkles at the corner of the eyes is to overlook the dimension of spirit (Su Dongpo in Yu Jianhua 1996: 454): slight, at the threshold of the visible and barely distinct, they transmit an animation. Is this still a matter of representation?

THE 'BEAUTIFUL REPRESENTATION
OF A THING'

A basic conception has prevailed, in fact, in classical Europe, and one does not see it anywhere even brought into question: it belongs to what I would call its *fundamental understanding*, stemming from the very tool of thought—philosophy therefore has no grip on it (it will require the rupture of modernity to shake it). Kant took it up after so many others but when he came to treat the work of art (at the end of the third *Critique*: §48) considered it as self-evident: 'A beauty of nature is a *beautiful thing*; beauty of art is a *beautiful representation* of a thing' (ibid.: 172). This is as good as a definition. To *re-present* gains a foothold over 'presence' (*praes-ens*, in Latin) which itself gains a foothold over the *ens* of Being which the

reproduction by art is said to be. And so it is all linked up; or when presence is no longer made explicit as such, it remains this *vor* of a 'bringing forward' (*vorstellen* in German). It even links up so well that there would be a danger of no longer noticing what it contains that has value through its status as a major presupposition, from which everything then flows. But it slips over it, it is true, as though it was there only as a minimal and such a neutral support—there is a 'thing' in play (*Ding*) which would be 'brought forward'. In other words, some constituted being had always been there, *brought forward*, posing as the model before the painter, with a stable form, isolatable, transferable and nameable even if in the most vague way: a 'thing', of which the work of art, equally a 'thing' but in another way, needs only to be a duplication—*Verdoppelung*, as Hegel said—oh so finely wrought. 'Beauty', *Schönheit*, is then propelled as the necessary concept expressing the profit to be found in this operation.

Beauty will therefore be a matter of 'representation', and representation itself, even if it hardly emerges, rests on the immense base of ontology—it is on this supposition that 'things' are always dealt with; it will always be a matter of something, *ti* said the Greeks, in a way admittedly as indefinite as could

be but already set, and offering the consistency of an object (first of an accusative: let us not forget the terrible assault of Aristotle when he ordained that 'to speak is to say', and that to say means to say 'something', *legein ti*, without which the word would be unmade and sink into inanity—it would be tipped outside of humanity (*Metaphysics*: Gamma; I consider this in Jullien 2006). This very compact consecution leading from the 'thing' to its 'representation', and consequently so difficult to crack but which, as such, has formed the bed of classical philosophy in Europe, all of a sudden could finally be illuminated from afar—by divergence, once more, from the Chinese outside. So massive is this fact:—there is no term in Chinese which can express 'representation' (*xiang* 'image-phenomenon' expresses the configuration). On the whole, this is logical since Chinese thought has not developed in the ripples emanating from Being but in terms of process (*dao*): How could it consider what we call a work of art, *Kunstwerk*, as the representation of a 'being'? This divergence is still bigger (and corroborated)—ancient China also did not imagine theatrical representation either, which was undoubtedly, from the Greek side, the anthropological framework within which the philosophical concept of *mimèsis* prospered.

More significant still appears to me to be the fact that European translators always re-introduce the relation of representation, as through it was a question of a necessary join, and so do not engage with any-thing—in the very place where the Chinese do not say anything about it, in other words (for us) leave a void that we hasten to fill up. Some examples: 'I have at home,' the translation goes, 'six paintings by Li Cheng [representing] snow landscapes'; or 'two very ancient paintings [representing] pavilions and ter-races' (Mi Fu 1964: 62, 64) The Chinese, however, is content with saying (Mi Fu): '[of] Li Cheng—snow—scene—six rolls' or 'two rolls—pavilion(s)—terrace(s)'. One statement: the Chinese thinker did not need to *refer* painting, fixed as an artefact, to a 'something' which would be of the world. 'When the Ancients painted trees,' Pierre Ryckmans translates, 'they represented them in groups of three, five or ten, depicting them under all their aspects, each accor-ding to its own characteristics' (Shitao 1984: 93). But Shitao says precisely: 'When the Ancients traced Trees, in threes, fives, nines, or tens, they did so in such a way that, in one sense or another, whether *yin* or *yang*, each would have a characteristic aspect.' One could certainly consider, once more, that such an addition is just an adaptation; that its intention is

simply one of convenience—such 'representation' might be implicit in Chinese while the European language needs to make explicit the implied relation through a concern with clarity. But I wonder: Is this not to yield, in a strange way, to complacency? Does it not immediately bring us back into the matrix of our accepted conceptions ('to represent', 'to depict', 'its' characteristic aspect . . .), which, connecting us up with an other possibility, would therefore demand to be thought in a fully fledged way—and even as an opportunity not to be missed? Once again, it is worth the trouble to draw on this thread to see what it brings behind it.

For what stands out *behind*, on the European side, is nothing less than the way in which we have conceived of our capacity of knowing, before even that of creating, the 'representation' that intervenes at two levels and forms a link between them: on the one hand, between the mind and the world, of which the work of art is a reproduction; and, on the other, within the mind, in advance—my ideas are themselves representations. Kant passes from one to the other—if the work of art can be the 'beautiful representation of a thing', this is owing to the internal power of representation which is characteristic of the imagination. Kant called 'aesthetic Ideas' those representations

which furnish the imagination, going beyond every determined concept and consequently provoking thought with more than anything discourse could express. In this way, what everyone knows will be explained—that art is always richer than what can be explained about it. From one degree to another, 'representation' is a concept which, in splitting itself into two, expresses at once the *relation* which the work of art maintains with the world and the *contribution* of the artist in his creation (thanks to the transfiguring power of the imagination), so accounting in this way for how—an account as old as our concept of art and of which it was the enigma—a beautiful representation could be produced of an ugly thing. *Representation* will be therefore the explicative concept, and as such sufficient, of beauty: 'Beauty may in general be termed,' concludes Kant (whether it is natural or artistic beauty), 'the *expression* of aesthetic ideas' (1978: §51).

I must nevertheless confess that I no longer find Kant so convincing here. And even that he appears to be toiling to hide the forcing by which he was able in this way to arrange the activity we call artistic under the reign of representation alone. What, in fact, was his starting point (at the beginning of paragraph 49 of the *Critique of Judgement*)? It was what he called

Gemüt, which is something quite different, of the order of the affective, the mood and feelings. He then speaks to us, piling on the examples, about what is 'soulless'(*ohne Geist*: a poem can be very well and elegantly made but be 'soulless', and so on; or a young girl can be pretty, have conversation and bearing, but be 'soulless', and so on). In this case, 'Soul' (or 'spirit', *Geist*) designates, 'aesthetic sense', which he defines as the principle which 'gives life' (at the heart of the *Gemüt*). Then, without a further transition, Kant puts forward in a tone of trenchant affirmation (*Nun behaupte ich* . . .) that a fine principle is nothing but this *representation of the imagination* which he calls an 'aesthetic idea', and in so doing goes back to his basic categorizations—in fact, he returns to where he feels comfortable: those representations of the imagination overflow the concept and form a counterpart to the ideas of reason; in the first case, it is the concept which is not suitable for the representation of the imagination and, in the second, it is the imagination which is not suitable for the transcendent concept of the supra-sensible and so on

In introducing this level of representation or, rather, in order to introduce it, Kant has therefore abandoned, without further justification, the levels of sentiment and the affective and suddenly slips into

the pure intellective (even if such a representation of the imagination is then freed from the tutelage of the concept)—we then effectively find ourselves in the terrain of knowledge, caught just in the play of our faculties. Hence the question: What constitutes the thought of beauty, isolating itself as it does on the level of the representation alone (beauty as the 'beautiful representation of a thing'), if it causes us to lose comprehension of the work of art as we cut ourselves off from the *Gemüt*, sentiments or internal dispositions, and the 'vitalizing' principle (*belebendes Prinzip*) which belongs to it? Why should the *Gemüt*, which we are nevertheless well aware—as was Kant—still inhabits the process of the work, of which it is through and through the condition, be left to flee (left to die) under the tutelage of the 'idea'?

I pose this question because this is precisely what Chinese thought, not functioning according to the resultative perspective of the beautiful, does not have to do—it does not distinguish internal motivation (the *Gemüt*) from the power of the representation. One notion (*yi*, 意) expresses the two inseparably, as centrally as 'representation' does in classical European thought; it also effectively expresses the 'urging' to paint what is 'conceived' in the mind of the artist before he takes up his brush, as well as the 'meaning'

expressed by the painting that is equivalent to a poetic sense. What binds them together in this way, that this term does not allow to decompose? In it, one level of (beautiful) representation cannot be left isolated ('intentionality', if this was not too technical, would reconcile it owing to its phenomenological precision— not to lose the originating or the entirety of the process engaged in). Guo Xi tells us on the same page and still by using the same term *yi*, 意 ('On the *yi* in painting') that before painting, a fortunate and pacified (*yise yueshi*) 'disposition' (1) should be nourished within oneself, while a 'feeling' (2) that is contrary to oppression forms an obstacle (*zhiyi*) to it; then that a 'visualization' (3) operates in the artist's mind as a result of silent maturing as well as in relation with his capacity of execution (which is experienced 'in the hand': *qiao shòu miao yi*) and is the opposite of the depressive 'state of mind' (4, *yi*) which would cause his work to fail; finally, the 'vitality' (5) which is transmitted in the painting (*sheng yi*). This same term, repeated and varied so many times, expresses just on its own what is freed from internal propensity, favouring the propagation of the figuring line, and the impact it can make. Like other Chinese notions, it too is not cut off from what is energetic.

In this process, no place is therefore left for any thought of the beautiful because (from the prompting that mobilizes the painter to the realization of the painting) no rupture occurs from which, as the work comes to be inscribed in relation with the world, a relation of representation could be instituted. We are aware that to paint is not to depict (just as to write is not to describe)—to depict isolating a 'before' and constituting it as an 'object'. As a result, no moment is introduced which might cause the artist to aim at the beautiful as occurs in the course of painting a Nude, as much as he probes in a passionate way the form before his eyes in order to reproduce it as to seek to render it ideal. Everything here, on the contrary, tells us how the painter above all slowly devises his figurative schemes when, in his wanderings, he progresses by contemplating the coherent way in which energy is actualized in the most diverse forms: then how, when he feels himself suddenly borne along by his internal disposition, in conformity with the conjoined engendering of ink and brush, the work immediately realizes itself—there is no place there for the mediation that would be fulfilled by 'representation': when he takes up his brush it is, we are told, 'as though it was already done' (Shitao 1984: Chapter 4). 'Mountains and valleys are to be found as already

contained within the breast and, when the ink falls, naturally the mind moves quickly' (Fang Xun 1962: 30). It is then sufficient that nothing, in his internal disposition, should come to create an obstacle to what is transmitted so continuously from his 'heart' (or his 'spirit', *xin*, 心) to his 'wrist'.

The *Arts of Painting*, therefore, enhances endlessly not through the faculty of representation but by using something that comes earlier in the process, the *availability* to which the painter knows how to gain access and that allows the emptiness within him to emerge, an availability a lot more 'difficult' to acquire than what is either commandeered or obtained by effort. This is the decisive capacity that takes the place of our 'inspiration' (but one that lacks a mythology—it has no relation, whether or not feigned, to transcendence). Guo Xi had spoken about how, if his 'internal disposition' (*yi*) were fortunate and pacified, free, clear and released, 'then the expression of human features, whether happy or sad, just like the characteristics of things, as varied as they would be in their aspects, would be naturally deposed and ordered in his heart' (*bu lie yu xin zhong*: once again translated as to 'represent'—Vandier-Nicolas 1982: 96): 'without his realizing it, it is there beneath his brush' (Guo Xi 1960: 'Hua ji', 24). Shitao also returns to this point

in two successive chapters: 'When someone allows himself to be hidden by things, he consigns himself to the dust; when he allows himself be employed by things, the mind becomes over-worked'. Or: 'When one allows one's mind to toil in the minutiae of the brush, one will be destroyed; when one allows the ink and the brush to be hidden in the dust, one will be constrained'. Man 'then limits himself in it and there is only loss and no gain and finally he is unable to render his mind alert' (1984: Chapter 15). No true painting can emerge from it.

'But for myself,' Shitao proudly says, 'I allow things to hide themselves by following things and the dust to consign itself to the dust; so my mind does not toil and, as it does not toil, there is painting'. Painting is born *sua sponte* from this internal disencumbering as it generates availability. Consequently painting demands hygiene—near a bright window, on a clean table, after having burnt a stick of incense, without allowing oneself to be any further disturbed, the mind at once detached and concentrated, and so on (Guo Xi 1960: 19). Once trained, the receptivity of the painter along with, over the years, the laboriously acquired aptitude to handle ink and brush, were—*in loco* of the work of representation aiming at the objectification of the beautiful—the conditions of

improvised engendering of the pictorial line that then become decisive; as such they are sufficient. But for all that, is this something with which we could be satisfied? Even if there is no place here for the beautiful from the point of view of production, once the painting is done and I look at it (that is, from the point of view one calls reception), will I nevertheless not inevitably say: 'it is beautiful'?

'HOW BEAUTIFUL',
OR WHAT CAN I DO BUT 'JUDGE'?

When I stand in front of the blue-tinted hills varie-
gated with vine and olive trees beyond the pink roofs
which border the Arno, will I not, indeed, say 'How
beautiful'? Can I avoid this eternal word of tourists,
this banal and even hackneyed statement, this state-
ment which everyone in turn has invoked? Do we not
understand it as a human exigency, even perhaps as
the only one which reconciles our humanity? That of
having to impart in this unique term, even if only by
murmuring it to oneself, that one carves out and dis-
tinguishes what is then offered before our eyes and
that the suddenly gratified gaze desires to carry away.
'Beautiful' is the qualifier with global approval of this
'thrown before' the view (and in 'full view') of what is

then considered as an 'ob-ject', and as such it cannot be ignored. In the same way, standing before Bargello's bronze forms or the clear and well-defined colours of the apostles, and their poses, in the Brancacci chapel. *Standing in front of them*, what can I do except discriminate and predicate at the same time: 'How beautiful!' Who would like to extinguish this typified cry of confession which spreads in a unanimous (but anonymous) rumour like a sign of recognition among the human masses and that everyone will have unfailingly have on the tips of their tongues? And I will certainly do the same, if I *formulate a judgement*, when I stand in front of the winding cascades and pines, and the vales from which the clouds rise in the paintings of Guo Xi. Just as much, I will resort to this word of the past. I will inevitably also pronounce 'How beautiful'.

But what am I doing when I say 'How beautiful'? I am indeed *defining*, at once I am distinguishing and underlining, I am designating and promoting, but perhaps also even as I do so I put away, place apart and rid myself of it. The word 'beautiful' homologizes and labels; consequently, the receipt has already been given. In this 'standing in front of', the 'beautiful' carves, and detaches; it wants to carry you away; but once this judgement has been pronounced, we are

freed from it. As when we take a photograph and place it in a box—the tourists return to their coach with a sense of relief, at the appointment with the beautiful they have checked off. I distrust this 'How beautiful!' because it is a convenient way of settling, of bringing it to an end, as they say, of taking leave of it. Or perhaps it is precisely this 'being in front' of presence (of *prae-ens*)—which the re-presentation echoes—that did not go without saying: I plunge into the deserted vales which a hand so amazingly endowed has caused to spring forth, as the *Arts of Painting* of ancient China says, I ramble around it, wandering, 'evolve' in it (*you*; reread the first page of Guo Xi on this subject). I will haunt these mountains and waters, traversed by their endless interactions, refreshed in them, forget the world and regenerated myself in it. . . . I still weakly perceive the cry of monkeys and the surge of the waterfall. . . . If the judgement of the beautiful is not constituted by it, it is because it does not assume consistency in it—in this 'atmosphere'—such a pellicular relation with objectivity. Beautiful as a word is inescapably linked to this *in front* of an in front of the world—of an 'in front of' which, cutting up by the gaze, suddenly calls to be distinguished in it, to pronounce itself halted and to be judged. Halted before the world as before a Nude.

To judge ('How beautiful') is the compact verb which passes through European thought and is found in one language as in another. Cutting between terms so dramatically alternative in their monolitheism means that it is transposed from the judiciary institution into a particular faculty of the mind. Beautiful *or* ugly are aligned with true or false, or good or evil. But it is especially in connection with the beautiful that judgement is revealed as that faculty to cultivate in and for itself. Faced with the beautiful, said Plotinus, the soul 'names as from an ancient knowledge' (*Enneads*: I, 6, 2), it pronounces (*legei*) and 'recognizing, welcomes it'. 'And the soul includes a faculty peculiarly devoted to Beauty—one incomparably sure in the appreciation of its own, when the Soul entire is enlisted to support its judgement (*eis krisin*)' (ibid.). This power is said to be the most powerful, in fact, because it is master of its decisions and depends only on itself in the face of submitting to being 'cut up'. The political ideal Europe has deve-loped is inevitably understood against this background: 'How beautiful' expresses—poses—this hegemony of a subject affirming its autonomy in the face of what before it becomes the world. What it carves up and recognizes about the 'beautiful', it considers unambiguously at a distance and submits to the

jurisdiction of a 'self'. From what would this faculty of the soul judge, as Plotinus continues, if this is a rule enacted from within? It 'acts immediately' because 'it finds something accordant with the Ideal-Form' (*eidos*) which is within it, this ideal-form of beauty of which it uses 'as a canon of accuracy in its decision' (ibid.). From this 'to judge' (*krinein*), sovereign as it is, is born the function which will be called 'critical' and whose specific stake is the beautiful. Classical thought in Europe would emerge from neither. It persevered with the idea of a faculty of judging which 'clashes', as Kant again says, 'in matters of fine art bases its decision on its own proper principles' (Kant 1978: §50); and conjointly of the beautiful as the proper object of this capacity of judgement and revealing it. The one evolved in the pit of the other— we would not have thought so much about the 'beautiful' if we had not elaborated this central operation of 'Judgement'.

Let us consider Kant's starting point. Once again, the first sentence already expresses anything without envisaging what is implicit within what he proposes and to which he holds this 'anything'. In order to make a start, what is it that Kant says, not in relation to the creations of art evoked *in fine* and from the perspective from which we have approached it, but

from that of a judgement of taste defined above all, from the first note, as the power to bear judgements of appreciation about the beautiful? 'If we wish to discern whether anything is beautiful or not,' says Kant in commencing, 'we do not refer the representation of it to the object by means of understanding with a view to cognition [. . .] but by means of the imagination' (ibid.: §1). From that point, everything is maintained in this triangle: (1) appreciation rests entirely on this 'judgement' which deliberately delineates an alternative: beautiful and not-beautiful; (2) it is representation, *Vorstellung*, which serves at once as unique support and as intervention in this judgement; (3) the operational distinction is that of the subjective and the objective, the subjective experiencing 'itself' in the judgement of the beautiful such as it is 'affected by the representation'. The three are, in fact, held together, connected by the beautiful. The beautiful allows a specific power to be distinguished by which to discern and to judge which would not be the determining judgement of knowledge, but this 'reflective' judgement (and this as we know is the most decisive contribution made by Kant in this domain) now operating without a concept and no longer referring the given representation to the object but only to the power of representations through which a subject

gains experience. On the other hand, this also enables him to distinguish the sensation of the 'agreeable' which avoids this stage of representation.

It is true that this notional tripod (of subject, judgement and representation) upon which the beautiful is supported in classical Europe has since been borrowed by the Chinese, who today can even be seen to be using them without any reservations. The steamroller of theoretical globalization has passed through there as well. And so they have invented the notion of 'the subjective judgement of the beautiful' (*zhuguan shenmei*) by translating it from the Occidental, and they use it even in the translation of the *Shitao*, rendering it unreadable (see Li Wancai 1996: 205). In the same way, the notion of artistic or literary 'critical discourse' (*ping lun*, 评伦) has become established. Yet once more I have to wonder, against the current of this assimilation which few people detect: Does this not, under the cover of greater conceptual rigour, illustrated by the West, surreptitiously bury other forms of lucidity that have not passed through these implicit choices and which could equally well advantageously inform Western thought? In what way does this function of 'judging', as it is conceived, effectively correspond with what is contained in the ancient Chinese character (*pin*, 品) which signifies at

once to class hierarchically and to arrange by rubrics or to categorize? Instead of stating that 'it is beautiful', I *class* as 'superior', 'average' or 'inferior' (or, in a more refined way, as 'superior-superior', 'superior-average', average-superior', 'average-average', and so on); or, instead of subsuming the 'beautiful' under a common term, which would then be called upon to diversify itself, I *arrange* according to rubrics that shade themselves reciprocally, forming a series which are considered in parallel. Where is what we call today literary or art criticism in China derived from? Not from procedures of 'judgement' (*krisis*, *Urteil*) but from the classifications of bureaucrats (in nine degrees, *jiu pin*), as they appeared from the time of the Han empire, two thousand years ago, and was then transported to the assessment of calligraphers, and then to the painters and poets.

We can discern the art that developed, in the evaluation of people, and from which artistic appreciation has flowed (*Shishuo xinyu*: Chapter 9, 'Pin zao'), from a collection of sayings, short portraits and apophtegms reported from court life in the third to fifth centuries, the principal testimony of which has been called 'pure communication', among members of the literate aristocracy (because it was freed of the concerns of the world, *qing tan*). I had been reading

this collection for a long time intrigued without, I admit, really knowing what to do with it. Because what theoretical gain could one draw from all this anecdote? What could be done with so many diverse comparisons, classifications and hierarchizations, without extricating, or even just thinking about coordinating, some unitary principle from the scattered rubrics organized in an apparently completely haphazard way? At the same time, there can be perceived in it the outcome of a silent valuation, ripening over a long period, striking in its laconic quality and judged worthy of being retrieved. At best, these lines of cleavage appear—so-and-so is inferior to a first character from the point of view of 'structure-energy', to a second from the point of view of 'simplicity-elegance', to a third of that of 'attraction-unctuousness', to a fourth of that of the 'flight of thought' (§30). Then the same categories would be taken up in the same way on the subject of a painting or a poem. Nothing further is said which would construct or simply explain and justify, and most often we are dealing only with images. Thus, faced with so much notional fluctuation without anything being defined, in which we are kept in the realm of the suggestive and see a parade of instances being classified and reclassified from various angles, but from which a

judgement of the whole is never constructed—and this occurs without there being any feeling of a lack, and even as though this was art of the most 'refined' type—we can understand how the 'critical' tool to be found in Europe finally offered a salvation that would hastily be adopted.

And so I started to familiarize myself with the entirety of this composite (yes, it is really is a question above all of *habitus* and not of intelligence) following in it how, however concise the appreciation might be, it referred to an inventive and yet only sketched and never thematized typology, but which condensed the dimensions of existence within it. In the end, for example, and always through polarity: 'I am superior to him in how to live in tranquillity and beyond the concerns of the world—he is superior to me in how to remain at ease on a solemn occasion' (§ 22). Instead of there being a monopolization of one criterion, appreciations are kept *balanced*. Branching out in this way through formulary characterizations from one page to the next proceeding through reconciliation, pairing off and comparison, without allowing oneself to be dominated by one notion, that are far more connotative than descriptive and which are barely predicative at all (and very difficult to translate, so impressive do they remain). Concerning one, who is

'serious, serious as if entering Court; without needing to cultivate respect, others naturally respect him'; of a second, 'as if one saw a weapons depot: swords and halberds before you'; of a third, 'vast and raising himself up without limits: there is nothing would not be there'; finally of a fourth, 'it is like climbing a mountain and looking below: withdrawn—secret—deep—far away' (Chapter 8, §8). These four estimations coming one after another suffice to form a system and they are deployed from one pole to the other, but without any of them imposing themselves. Even when it comes to people, the characterization in it is that of the *ambiance* which emerges from it; it expresses an influence exercised, a pregnancy accumulated and such that it goes through the whole setting; it already forms a landscape.

The appreciation of painters and poets was born nestled in this same term (*pin*) and in this wake. Poets have been hierarchically classified (into 'superior'/'average'/'inferior') under the title of *Poetic Evaluation* (*Shi pin*) which separates their weaknesses from their qualities (Zhong Hong in the sixth century). Or the poetic modalities forming a series have been evoked in such a way that each of them compensates for the excess that the preceding one might entail (Sikong Tu in the tenth century). Thus the first, 'primordial

energy', could lead to too much violence and confusion—from which follows 'Harmonious flavourlessness' (2). But this could lead to too much pallor and dryness—and so 'Adorning intensity' follows (3). But then this could lead to too much abundance and superfluity—'Hidden determination' follows (4). But this could become too dependent—there then follows 'Ancient elevation' (5) and so on. In this series of poetic modes and tonalities (twenty-four in all), no one notion predominates—there is no subsumption by the beautiful but a continuous equilibrium, passing from one term to another, in such a way that the estimation does not stop at any term but is renewed from one mode to the next and keeps the range open. Instead of one seeking to define a unique essence and, because of this (necessarily enigmatic) fact, for which the West has a passion, the typology of the diverse is refined by a shading threading through each instance—an internal logic effectively leads from one to the other and the system forms a circle, but without any perspective prevailing from which one could give oneself over to the unitary act of 'judging'.

The same thing goes in painting (the same categorical use of the character *pin*, 品); painters are systematically appreciated by comparison with one another and in parallel; they are classified from high

to low according to hierarchical degrees (from the first treatise, by Xie He, the *Gahua pinlu*). Even in relation to the greatest, the evaluation is made by a concise evocation in terms of 'energy' and 'resonance' or, rather, of 'muscle' and 'bone structure', of access to the 'dimension of spirit' (*shen*, 神) or the handling of the brush that is so successful that it appears natural (*miao*, 妙), and so on. 'One could have fun in examining' the paintings of pretty women (*xi yue*), Mi Fu tells, but would be unable to 'penetrate' with them into a 'limpid play' (*qing wan*, 清玩), released from the rut of things and ordinary expectations (Mi Fu 2000: §158; see also Vandier-Nicolas in Mi Fu 1964: 205). I do not know how better to render this not very analytical expression but which suggests that the mind evolves at its ease in its dealings with painting, freeing itself from codifications and constraints, and that it touches the inexhaustible. To 'savour' (*wei wan*, 味玩) is another term in use in relation to the appreciation of painting which, in the form of a tacit consummation indefinitely prolonged into intimacy, hints at once at the reabsorption of the two—of that externality before which one would say 'how beautiful' as much as of any principle, or an exclusive 'canon', in the name of which one could judge it. Admittedly, 'savour' will be understood as involving pleasure. But

is it still a matter of 'pleasure in the course of this savourization which has allowed the sensation to decant so well that the savour became 'flavourless' and its perceptibility is in the process of meeting its erasure? The spirit will then 'pour out', they tell us simply—it unburdens and deploys itself by following upon the silk the mists arising from the midst of the vales and forms dispersing vaguely—here and there, between a 'there is' and 'there is not'—in the process of dissipating.

XVIII

IS IT A MATTER OF PLEASURE?

During the period in which aesthetics was born, there was unanimity in Europe about this point—what defines the beautiful is that it 'produces pleasure within us', precisely that of *aisthesis*. We *judge* the beautiful contingently with *pleasure*, as Wolff, Diderot and the Scots all agree. And so the alternative of the beautiful and the ugly comes down to that of pleasure and its contrary; or, to express it in a more analytical way, it is pleasure which serves as predicate to the judgement of the beautiful. Let us look once again at Kant's starting point—to distinguish if something is beautiful or not it is enough to relate the representation of it, within the subject, to the feeling of pleasure or pain the subject experiences (*Lust/Unlust*). What separates the judgement of the beautiful from that of

knowledge is that we then become aware of the representation given to us in favour of a sensation of satisfaction, which is tied to the feeling the subject has of being alive and, as such, says Kant 'intensifying' his life. This operative distinction leads us to our point of departure—in the pleasure which the beautiful defines, we no longer link satisfaction with the existence of the object of the representation but to 'simple representation' itself (*blosse Vorstellung*) and to what we make of it within ourselves.

We already know the separations which follow and which result in making aesthetic pleasure, for Kant, the turntable of his philosophy—even if it might even turn all too well for the profit of the entire system (to the point that it is through it that a system exists)? Purely contemplative, the pleasure of the beautiful, as we know, is equally to be distinguished from the 'agreeable' as from the 'good', both of which are concerned with the existence of the object of representation and therefore mingling pleasure with the power to desire: the first limited to the stimulation of the senses, the second presupposing the concept of a duty to exist and serving the practical interests of reason. Now, because this feeling of pleasure that produces the beautiful is allowed to lead to neither one nor the other, neither to the matter of sensation nor

to the prescription of reason, it makes a break as much with respect as with inclination, separating itself as much from the concept of perfection as from attraction and emotion but, as such, being untied from desire (which finally liberates Kant from classical anthropology and thereby to establish the autonomy of art) was enough to reveal a third term linking the two great parts of philosophy: on the one hand, the power to know Truth (according to the laws of nature); and, on the other, that of desiring the Good (according to the laws of freedom). The power to experience pleasure revealed by the judgement of the beautiful accomplishes the passage from one to the other. One might fear that once more Kant, like all metaphysicians before him, was content to make the beautiful, *via* pleasure, play the role of a convenient mediation, but he knew how to describe what this pleasure actually consists of.

Indeed, from where does this feeling of a blossoming of life emerge such as to give birth directly to this pleasure of the beautiful? We know that Kant responded to this through the way, at once spontaneous and proportionate, in which our two representative faculties, one perceptual (imagination) and the other intellectual (understanding), play in relation to the other—imagination composing the diversity of

intuition and the understanding unifying representation by means of its faculty for concepts, but without the intervention in this case of a determined concept, since that representation does not serve knowledge. What enables us immediately to experience pleasure in the representation of an object we judge to be beautiful therefore relates to the harmonious relation stirred up between the imagination 'in its freedom' and the understanding 'in its legality' and, consequently, in the reciprocal animation that flows from it. In this there really is a 'free play' which is not without recalling the 'limpid play' (*qing wan*) evoked for their part by Chinese literati; for Kant, however, this play (*Spiel*) is defined as what the faculties of knowledge maintains between them. This is what creates a problem in the Kantian enterprise of clarification and bears precisely, I believe, on these two moments. The accent placed first of all on pleasure alone (*Lust*) will be too restrictively sensualist (in the spirit of the eighteenth century), despite the care Kant took to distinguish the sentiment of pleasure from sensation (against the 'confusion' the *aisthesis* maintains within it; but can sensation-information and sensation-satisfaction be separated to this extent and is the distinction between objectivity and subjectivity enough to establish this separation?). *Then* the accent

placed on the play of the faculties of representation alone will be too intellectualist, in spite of the freedom Kant recognized in it, since it is then simply a question of the faculties of knowledge, even if—which remains a paradox—it has then ceased to be just a matter of knowledge. The *Gemüt*, once again, is discovered in the course of the forgotten path. And it is still the same old dualism we found before this difficulty and that caused us to topple from one side and *then* from the other.

But what does the Chinese literati relate about the experience he has before a painting? Above all, is it (objectively) correct to say 'before'? *Dui,* 对,which the Chinese texts generally use, means both what is found in relation to, what is coupled up with and what one responds to (and if this term has been used to translate 'ob-ject' into contemporary Chinese (*duixiang*), it is unfortunately by dropping these relations of coupling and connivance). Dealings maintained with painting, as one of the first authors of treatises on landscape painting, Zong Bing, in the fourth century, confides to us, has its point of departure in an internal availability evoked emblematically according to informed attributes (the control of the breath, wine and music), from which an intimate process follows:

Holding [*myself*] *in peace,* [*I*] *rule my breath-energy,*
wiping [*my*] *cup and causing* [*my*] *zither to resonate,*
[*I*] *unroll paintings and I confront them*
(*respond to them*) *in divergence* [you dui],
sitting, [*I*] *explore the four corners of the world*

(Zong Bing in Yu Jianhua 1996: 583).

As we might expect, the translator into French has symptomatically introduced an 'I look' which nothing in the text supports (Delahaye 1981: 105). (The non-sinologist is no doubt weary of these remarks concerning translation, but it should be understood that all of these small additions, serving as compromises and rendering the translation 'smoother', mean, in the end, that we are always dealing only with variations of the same and that, while believing we are reading Chinese texts, we are still sitting at home.) Equally, it needs to be pointed out that these paintings are not exhibited (in a fixed and permanent way, like pictures), but are *unrolled* at particular times, according to the moment (and contributing to the quality of the moment), for oneself or among friends. In this way, the idea of accompaniment and partnership that engages directly with the (painted) landscape is privileged against any objectivizsing perception, so not allowing

a relation of representation to be constituted—as we can appreciate from the following:

> *Without going against what solitary celestial rigour accumulates,*
> *solitary, [I] respond to the uninhabited extent:*
> *haughty and grandiose peaks and summits,*
> *of forests in the clouds extending into infinity . . .*

The relation entered into with the (painted) landscape, by inviting the majestic forms to circulate at will and to the point of their effacement, unblocks and unfocuses internally; it becomes serene and reconciles. Thus it is precisely a question of neither one nor another; it is neither the feeling of pleasure giving substance to the beautiful nor of functions of knowledge being freely exercised under its stimulus, but it is concluded in a unitary way:

> *What then remains for me to do?*
> *Let the spirit pour out and that is all.*
> *To this outpouring of the spirit*
> *What could one prefer?*

As a Chinese category, would this free *outpouring of the spirit* therefore be opposed to *pleasure* (a sensation or a feeling?). But let us not forget what 'spirit' means in Chinese (*shen*, 神): above all, it is not the agreement of the faculties of a knowing subject but a

refinement and a decanting of energy which, from being inert, becomes more alert—instead of being fixed and opacified, it is spread and deployed. There is then soaring and animation, as Kant describes, but without these becoming disconnected from what is vital and allowing themselves to be intellectualized (but also, which is the cost of the Chinese option, not allowing themselves to be analysed).

Wang Wei, another author of a treatise of painting in the fifth century, concludes in the same way:

> *Verdant forest—unfolds the wind;*
> *spumy water splashing the ravine:*
> *tires! How to cause it to flow as in the palm of the hand,*
> *so that the light of the spirit descends*
> *—such is the nature of painting*

(Wang Wei, 'Xu Hua' in Yu Jianhua 1996: 585).

Here again the rupture operated by the representation does not appear: 'spirit' does not lead to a separation between objective and subjective; the contentment evoked does not allow us to think according to two, admittedly inseparable, faces: of a feeling of pleasure on the one hand, and a play of cognitive faculties on the other. If satisfaction there is, it is of the order not

of sensation ('of pleasure') but of internal freeing and soothing. 'Each time I enter the empty and silent room,' Guo Ruoxu tells us at the beginning of his treatise, 'I suspend a roll high up on the white wall and I spend the whole day there facing—with-drawn—and responding to it (*you dui*, 幽对): radiant as I am, I am no longer aware of the grandeur of the Sky and the Earth, nor of the complications of things; still less am I worried by the eventualities of favour or disgrace in the world of power and profit; nor do I speculate on the chances of success or failure . . . ' (1964: 52). Have done with haste and internal congestion, continues the author, evoking a disposition which, as such, is not strictly aesthetic in the way that Kant steers the autonomy of the beautiful to it *via* pleasure. For it participates equally in what in Europe we can no longer give a name to other than grudgingly, so strongly has this term been ensnared by centuries of religious sensibility; nevertheless, it suddenly recovers all its meaning in the face of the extraversion of sight which has so thoroughly dominated Western painting—no longer the gaze but the 'gathering'. *Gaze* or *gathering*: To what extent do they in fact form an alternative?

Fang Xun and Kant were contemporaries. They belonged to the last period in which their two worlds

had yet to encounter each other in thought. What then does Fang Xun tell us about how to appreciate a painting? Concerning what the brush strokes of the Ancients left to us, whether it be simple or complex, one 'contends with and responds' (again this sense of *dui*) in a 'calm and silent' way (*muran*), one 'meditates' upon it by 'letting oneself expand far away from one's thoughts' (*youran*) and the 'spirit is going' (1962: 41). This is the 'serenity' appropriate to painting and 'no more worries are revealed'. The translator into contemporary Chinese thought it would be a good idea to add at this point the indication of a 'pleasure' (*xinshang*: have we not indeed been *globally* aware ever since Kant of the pleasure that is aroused by the beautiful?); but the term isn't there and it even appears obvious that there could be no question here of 'pleasure': in connivance with painting, one remains 'pensive'. *Pensive* is the exact modality of this relation to painting. It could equally not be a question, strictly speaking, of 'dream', as people in the West sometimes satisfy themselves with saying about Chinese painting, since here there is no distraction or transfiguration; it is rather a 'filtering' (a refining-decanting), if we could also scrub these terms clean of their bloated subjectivism. (Painted) clouds, Fang Xun tells us, 'bathe' the conscience, flowers and bamboos 'satisfy' our affective

nature (ibid.: 97). Concerning the paintings of Ni Zan or Huang Gongwang, each time at the heart of 'flavourlessness' there appears their fundamental capacity, which 'rests' the mind of those who are intelligent while it soothes the excess of energy of those who are violent (ibid.: 108). Yet those who enter into relation with these paintings should also position themselves so as to accede to their 'limpidity' and raise themselves to their level—they cannot count on what Kant put forward as the play of the faculties of knowledge as the universality of the beautiful.

XIX

DEMOCRACY OF THE BEAUTIFUL

The success of the 'beautiful' in Europe has no doubt been owing to this fact, which has gone hand in hand with the social development and political choices taken in the Western world as a whole—the beautiful is accessible to everyone. By rights. The promotion of the beautiful has gone hand in hand with the political recognition of the masses, and this is how the figure of *homo aestheticus* has effectively been the bearer of our modernity—the judgement of the beautiful reveals a community and an equality of subjects, both of which are set down in principle. This is the decisive gain operated by the beautiful which Kant knew how to exploit. Owing to the fact that the satisfaction of the beautiful is disinterested, and therefore independent of the subject which experiences it, it can be

deduced that it must have value equally for every-one. Not being able to attribute the judgement of the beautiful to my individuality, I can legitimately assume that each person shares it. A great Kantian argument: we can say 'I find it agreeable' (at the level of the judgement of the senses), but 'I find it beautiful' would be contradictory because the beautiful in itself depends upon the approval of others. This is why the beautiful will be spoken about as a property of the object although, in the judgement of the beautiful, as we know, the representation involved still refers only to the subject as to the pleasure it feels in itself.

But how can such a universality of the *judgement of the beautiful* be justified since the judgement oper-ates without that tool of the universal that alone can be the concept and, moreover, that it would be impossible to pass from a concept to the feeling of pleasure what no one can experience except in a per-sonal way? Especially if this 'universal' is given the strong sense of a duty to exist, as Kant wanted, instead of making it simply the report of an empirical and comparative generality, to the point that, even if I see others around me contesting my judgement of the beautiful, I will no less continue to require that they approve it. This is where Kant took such good advan-tage of the dissociation he brought into feeling and

judgement, or the sensualist and the intellectualist face of the beautiful, that is, the sensation of 'pleasure' on the one hand and the 'regulated' (*regelmässig*) relation between imagination and understanding on the other, as faculties of knowledge, even if, as we know, it is then not a question of knowledge (taking advantage so well that one could not fail to suspect him of having had this advantage as an aim and therefore of having conducted the preceding analysis only as a means). Since there is no universal of representation except in relation to knowledge, it is therefore only because the judgement of the beautiful puts the faculties of knowledge at stake that it can make a claim to universality (otherwise, if the feeling is empirical, the judgement is a priori)—that is, that it brings a conceptual faculty (understanding) to bear even if no particular concept ensues (this judgement not being determinant). It follows that it is the operation of judgement, indexed on knowledge, which is at the source of the feeling of pleasure, and not the opposite which would lead us back to the individuality of the 'agreeable' (such is the 'key' of the judgement of the beautiful resolving its 'enigma'); and that the 'pleasure' we take in the beautiful stems from the fact that it can be shared.

What is therefore essentially at stake in this judgement of the beautiful as it is analysed by Kant, and which in fact even constitutes a decisive turning for the coming of our modernity, is that it reveals a universality which, no longer able to be an objective universality, one of the order of knowledge, cannot be anything other than a new type—a 'universality of subjects'. It no longer rests on demonstration and truth (the 'apodictic') but on the very operation of judgement (in each subject) and assent (which is expected of others). This means that the Beautiful becomes the bearer of a new political conception or, even more, it turns politics, resting henceforth on the judgement of each person and appealing to the assent of everyone, into a new exigency of a humanity rejecting the transcendence of authority as outdated. If the beautiful is so important in modern societies, it is certainly not due to the surrounding aestheticization but, as has often been said, because it suffices, as prototype of political judgement, to dethrone earlier sovereignties. Moreover, we owe it to Kant to have shown that it is this 'shareability' of the sentiment of the beautiful (*Mitteilbarkeit*) which has led us to the need to present an a priori common meaning of the human (*Gemeinsinn*) that could not otherwise be attested—when I say 'How beautiful', I am producing an exemplary judgement of

a universal rule I would be unable to name (what is the universal of the human condition?) but that this judgement nonetheless illustrates.

At a stroke, this leads us to retrace our steps. Were we not too quick to mock it? This 'How beautiful' which tourists negligently let slip on the banks of the Arno or before Michelangelo's statues, this 'How beautiful' as a password of humanity, would, on the whole and as conventional as it appears, nonetheless be revelatory of a universal of the human which would otherwise escape us. More decisive still—it is in the light of this judgement of the beautiful that we learn to promote a universality of the human which might not be prefabricated. In the judgement of knowledge, in fact, the universal is to be found furnished as such by the concept of understanding and it is enough to apply it; but, in the case of the beautiful, the faculty of judging, as Kant shows, is called upon to *discover* the universal which *suits this particular* through the adequate play of the imagination and understanding. In this sense, the judgement of the beautiful puts humanity on the path towards a universal which is no longer given, delivered up as such by 'human nature' and so parachuted (into an ideological fiction), but now has a vocation to *produce* it from its *reflection*.

As a revealing illustration of how 'the beautiful' henceforth becomes useful for us—the universality of judgement of the beautiful is exemplary, in my opinion, of what must be the universality of the rights of man as the universality of subjects. At least, if one is no longer content to take these for the universalist *credo* that Europe has for so long made of them; or if, inversely, we are no longer resigned to relativizing them or even reducing them to some 'minimum' whose measure will then be very difficult to determine (I am referring to Jullien 2008: Chapters 10 and 11). Just as it can be the promoter of democracy in founding the autonomy of judgement—in the case of the judgement of the beautiful, as Kant underlines, it is 'each person' (*jedermann*) who demands to see and who judges by himself, without allowing himself to have his judgement dictated by another or, rather, allowing himself to be guided in the name of slogans or principles, gregariously and under influence. Since Arendt, this third *Critique* has often been re-examined from such a political perspective and it is, in fact, remarkable to realize the extent to which Kant was an innovator on this point—he wanted the univer-sality of voices to 'rally around'; the beautiful is the object of 'endorsement', it leads them not to dispute (which would be sterile since there is no question

of truth) but to discuss (which confers on opinion its democratic fertility), and so on. To the point that Kant lets us see how so much democracy can turn against itself in intolerance: simply by saying 'How beautiful', I am not allowing others to think as they want to; even contested, I no less require the adhesion of everyone, and so on.

Decisive in any case is the fact that the judgement of the beautiful applies to everyone and therefore, on principle, it involves everyone; consequently, in demanding the adhesion of others, it creates a *public*. If the mode of privileged appreciation in China in the realm we call 'art' differs from this, it is first of all, I believe, on this point—not so much because taste might be more aristocratic or elitist there (this reduction to the public is secondary and the West has also restricted it to the *happy few* while holding the vulgar at a distance), but because here one did not find the constitution of a public and a public space, something which is just as much verified on the political level, as is attested by the non- or under-development of democracy in China. Let us equally not forget the absence, in ancient China, of theatre and, before that, of the epic, not to mention the figure of the orator enunciating a discourse to the assembly—*agora* does not exist in China. Thus appreciation was formed through tacit transmission from person to person or,

more accurately, from interiority to interiority (*ishin denshin*, as the Japanese say), one person recognizing the quality of the other in a privileged dealing whose discretion is maintained. Thus, the universalist notion of 'How beautiful', as it sets up a *shareability* of principle which justifies anonymous, distant and unlimited communication, is here logically of little use.

We would give a better account of this art of discreet appreciation while being careful not to divulge too much, if we were to look again at the compilation of opinions, sayings and anecdotes which, as we have seen has inspired what we would call literary or artistic criticism in China (*Shishuo xinyu*: Chapters 8 and 23). At a time when Wei Yong kept office near to Wen Qiao, who liked him very much, 'Whenever he felt like it, he visited Wei Yong bringing wine and dried meat [. . .] sitting with legs apart [in other words, at ease and informally], they would spend the whole day facing each other' (again it is a matter of *dui*, of concordance and complicity) and 'when Wei Yong went to visit Wen Qiao the same thing happened' (ibid.: Chapters 23 and 29). It is enough to say that the relation they entered into, whose intimacy was enough and was alien to all protocol as to all hierarchy since it expected nothing of others, was excused from being divulged—not, strictly speaking, enveloped within itself but 'withdrawn', aloof from

chit-chat and value judgements and indifferent to all approval. This period of communion knows nothing but itself, and has no desire to be measured against anything, needs no approbation and makes no claim to being exported.

Another example: one night, when Xu Xun had an audience with Emperor Jian Wen, 'the wind was gentle, the moon clear and they had a conversation together in a separate room. Xu Xun excelled in the evocation of sentiments, but the clarity and grace of his expression surpassed those of other days [. . .] Although he was fundamentally in with tune him, the emperor on this occasion sighed with admiration and, without their realizing it, they would remain kneeling side by side and hand in hand while they spoke until dawn' (ibid.: Chapter 8, §144). Only the *moment* counts in this exchange, and to communicate at all about it outside would be of no interest—the occurrence is everything and nothing can be either detached or transferred from this circumstantiality. At the very most, the emperor would say, 'It is not easy to find people with such talent and sensibility!' A banal enough expression it may be, implying no judgement but signalling towards a plenitude which it would be a waste of time to prolong—or equally to share.

As He Xun was en route to Luoyang with the intention of assuming a post at the imperial court, his boat happened to pass the glorious Door at Suzhou; he was playing the lute in his boat when Zhang Han, who did not know him, heard him from up in a pavilion. 'Perceiving such clarity of sound, he went down to the boat to meet He Xun, and spoke with him' (ibid.: Chapter 23, §27). 'They both experienced great contentment in each other' and He Xun apprising him that he was going to the capital, Zhang Han, without even telling his family, decided to leave with him ... How would the person that is today (globally) called a 'critic' have been described in ancient China? Precisely by this: the one who 'knows the sound' (*zhi yin*, 知音). In the absence of the constituted idea of a public, personal receptivity alone counts—a good critic is the one who will elevate *in harmony*.

A chapter with this title is devoted to this function in the principal Chinese critical work about literature (recognized only later), the *Wenxin diaolong*, dating from the fifth century. After the usual complaints about the rarity of good experts, too many of whom were biased or lacked experience, it shows according to what tacit intimacy, from one interiority to another, this activity is conceived (Fan Wenlan: 2, Chapter 48, 'Zhi yin'): a contentment is born from it

'comparable', it is said, 'to what people experience in spring when going out on a terrace exposed to the rays of the sun'. Or the literary work exhales its beautiful qualities 'in the same way that, when one wears an orchid, its aroma emanates better' What can we draw from these images? This, at least: if there really are flaws and qualities still to be distinguished, in China the 'listening' to the work is done also by pregnancy and 'imbibition' (ze, 择), by isolating a resonance, even favouring an ambiance, rather than by theatrically calling public admiration upon it.

Everything then depended on the state of mind in which the work is approached. If you contemplate the painting of a superficial mind, said Guo Xi, you 'confuse the spiritual gaze/spectacle' and 'tarnish the clarity of the wind' (1960: 17). The 'wind', it is said: the flow again imperceptibly circulating and propagation; a 'clarity' also: it is always a question of purification and decantation of energy, without which it would be cut short between objective and subjective. In order to reach the 'clarity' of the work (qing, 清), it will be necessary to elevate oneself to its internal clarity, as is repeated to us, freeing oneself from all opacity which would form an obstacle to it—this is not so much a matter of elitism as of the capacity for detachment, it is stressed, and 'contemplation'. 'If you

approach the painting with a spirit of forests and springs its value is high; if you do so with an arrogant and dispersed spirit, its value is weak' (Guo Xi 1960: 17). As Fang Xun, the contemporary of Kant, said: everyone can see if the person who applied the rule and line is skilful or clumsy, but, when it is our internal stimulation that finds itself confided to the brush and silk, whoever does not himself have an elevated interiority as well as an uncommon perspicacity cannot gain access to what then happens that is so naturally successful (*miao*) (Fang Xun 1962: 23). A thought that is as banal as can be, taking up the old Chinese adage according to which 'best is the music, rarer are those who are in harmony with it', but which allows something more important to break through here: that appreciation depends on the conditions (of the moment, of the disposition, of the partner . . .) and does not posses the universal prescription that the beautiful abstractly assumes it to have; that, instead of arising as the act of a 'shock' of the beautiful imposing itself upon us imperiously and even with violence, it thus possesses a silent maturation and unfolding—in the sudden brilliance of an instant and 'striking' us as an event.

XX

THE DREAD OF THE BEAUTIFUL

When, after having skirted the first frescoes under the San Marco arcades, stopping before the *St Dominic* at the foot of the cross, with its immense blue, we emerge at the top of the stairs onto the *Annunciation*, we are effectively taken hold of, overcome, stupefied by this—suddenly prominent—*totality* of beauty. These words taken in the literal sense are not excessive, and it would not be going too far to speak of a suffocation that is almost physical. We feel attracted not only 'through the eyes', as the Greeks said, but also in the pit of the stomach, exactly as though it was the Virgin herself there before us just learning the News. We did not expect it. Something is uncovered which breaks with the previous time, going beyond calculation, and which we are called upon to confront—or

we must close our eyes and renounce it. Is this really a question of 'pleasure'? If there is satisfaction, there is just as much a feeling of being overwhelmed, because there is suddenly too much to see, the sensations overflow, the sensible has come out of its casing and its limitations and is now this, and no longer the Invisible, which assumes the role of the absolute. 'Ecstasy', the old term used by the mystics, is not out of place since it is really a question, when faced with this beautiful—this completely beautiful, this beautiful brimful—of a visuality which on every side breaks down the narrowness of our gaze, and is strictly speaking exorbitant (as if there was an active side to 'making the eyes bulge').

It this really a question of 'pleasure'? In any event, there is mingled with it the feeling of a lack, that of being unable to respond to this *totality* of what overwhelms us with beauty, from every side and with no remission. As it is the totality, it is too much (beautiful)—there is suddenly too much to look at. How can we be equal to it, to 'stand the strain', as they say, confronted with this torrent of perceptions? Instead of being able to contain these perceptions (that is, maintaining them calmly in their place), suddenly we are submerged in them. Admittedly, in order to recover a foothold, one could start to analyse the

painting, to break it up, to fix its details, to notice particular aspects of it and even to begin to comment on it, but this way would not be convincing enough to allow oneself to evade a tendency to dilute and deaden what had all of sudden become *visibly* too much. When I spend some time on the isle of San Giorgio in Venice, it isn't long before I can't take any more of so much beauty—to be continually challenged by this radiant outside, having always to have one's eyes turned towards it, having the gaze apprehended. The beautiful is literally blinding. The 'dread' of the beautiful, it has been said: To what extent is this monopoli-zation it imposes, this breaking in that it effects in the heart of the sensible, this presence from which there is no place to hide, really tolerable? I then aspired to faded and vague horizons, gloomier ones, where few things stand out, where at first there might not be very much to see; but only here and there, discreet, disseminated, towards which the barely attracted gaze is invited to look, developing as it pleased.

As soon as they thought the beautiful, the Greeks expressed, in the words of Plato, this amazement the beautiful arouses (*Phaedrus*: 251; repeated by Plotinus in *Enneads*: I, 6, 2 and 4). This beautiful becomes 'sensible' (*aistheton*) 'at the first attempt', it reaches us

literally as a 'feature' (*bolê*). Its springing up is sudden and unanswerable, just as the feeling it arouses is hopelessly entangled and even dangerously close to contradiction: it 'delights' and at the same time it 'scares'; it seizes us with 'dread' (*thambos*), 'strikes' our senses in a joyous way, arouses 'a dread accompanied with pleasure' (*ptoesis meth' hedones*). At the same time, it does violence and gives delight. Such an emotion casts us outside ourselves (*ekplexis*). In a similarly way to that of *erôs*, the panic it suddenly produces at the heart of what is sensible, which reveals a sensible which is no longer lacking, deficient as it ordinarily is, but on the contrary lets us touch the impossible (which causes the suffocation) as it exceeds perception.

Beauty provokes the gaze, holds it captive, it is riveted to it and petrified. 'What is it that attracts the eyes' (*kinei*) asks Plotinus, 'calls them towards it', 'pulls them onto itself' (*helkei—Enneads*: I, 6, 1)? The 'look fixed on beauty' (ibid.: III, 5, 1) is a privileged posture of Greek thought—there would not have been a reign of the beautiful if 'to contemplate' (*theôrein*) had not been promoted in parallel by the Greeks as a sovereign function. Indeed, such is the hegemony of the gaze in Greek culture that, even with regard to the invisible, the 'eyes' (of the soul) are

still 'turned towards' and attached; to contemplate is the perfect activity, it is that of the Sage and that of God Himself. What could the procession of the gods do if not contemplate the beauties of the world beyond? Just as the activity of the sage in China was not to contemplate but to 'follow' (*shun*, 順) and develop in concert, in the same way everything there spoke of the defiance experienced in respect of what would tend to provoke the attention and, saliently, seductively, it would come to break such a continuity of evolution (that which the *Tao* names):

> *Music and good cheer*
> *Give passers-by pause;*
> *[But,] when it enters our mouth*
> *The Tao is without taste or flavour*

(Lao-tzu: §35).

'When you look at it' continues the *Tao te Ching*, 'it is cannot be seen' 'when you listen to it, it cannot be heard'—not only does the 'flavourless' *Tao* not strike the ear or the sight, but at first we do not even notice it. On the other hand, when we 'put it to work', to 'use it' (the point of view is, once more, that of the function and is not theoretical), it cannot 'be exhausted'. The merit of what does not attract the gaze is to operate continually, without any further

amazement, and even without differentiating itself, and this is really why we did not at first pay it any attention; at the same time that, from thus always keeping itself in reserve, one could not grow weary of it. As there is no longer anything to aim at or 'target' (*zhong*), the commentator (Wang Bi) continues by saying that sight or hearing no longer give themselves a determined object, whether this visible or this audible, which refrain from hoarding, but discreetly display themselves; in that they are not attributable or defined, they are revealed to be inexhaustible. The same thing has been said about painting—the easy painting of 'artisans of the brush' is executed while seeking to 'please the eyes' and wanting to captivate the gaze; but, no matter how well it is achieved, our internal stimulation will soon be exhausted by it (Tang Zhiqi in Guo Xi 1960: 108).

Did the Greeks nevertheless only know this gaze of an instant, gratified to the point of stupor, a look of sudden ecstasy in the face of the beautiful, but which could not attain duration? Plotinus knew how to envisage a contemplation of the beautiful at the end of the ascension of the soul (intelligible, in the celestial World Beyond) such that neither tiredness nor satiety would threaten it, but that 'to see is to look for more', absorbing itself in its activity: 'to continue

in the contemplation of an infinite self' it would accord with the proper development of our nature (*Enneads*: V, 8, 4). We would then emerge from the dread and shock of the beautiful at the heart of the sensible to open them up to spiritual unfolding (but this is certainly possible only after having definitively broken from the sensible). In the same way, we see Kant, who reversed the effect of the bewilderment and shock on the part of the 'sublime' mingling the negative emotion of the jolt with the satisfaction of its surpassing (in the heart of the supra-sensible), envisaging in passing what it could be to 'linger' before the beautiful in conserving the very state of the representation at the same time as the activity of our faculties of knowledge (Kant 1978: §12).

Nevertheless, this subjective motivation that the activity of contemplating the beautiful finds in itself and which leads it to self-fortify and reproduce itself remains something quite different from the process of valorization appropriate to the sensible itself and it *deepens it*, in the way that Chinese thought describes, and which stems precisely from the fact that it is not from the outset 'beautiful' which draws attention to itself through events and makes itself noticed, still less admired. A commerce is engaged with painting which is revealed to be all the more pregnant and even

pervasive for having appeared for the first time according to the model of the 'flavourless' and the 'discreet'—according to the model of the *barely*. So much so that finally one can no longer detach oneself from it and it develops indefinitely.

The same thing occurs at first in commerce between people. The other great text of Taoism, the *Chuang tzu*, abounds in stories of beings who have nothing attractive about them, indeed who are warped, twisted or unstable, in a word: monstrous. But as time goes by they emanate such an ascendancy through their influence that even the sovereign can no longer ignore them (Chapter 5, 'De chong fu'). Or, in the compilation already cited and which gives form to the features of what was in the process of becoming the cultured conscience in China, it is often a question of persons who are initially coarse but whose principal mark of appreciation then arises when it is realized that one is no longer able to leave them (*Shishuo xinyu*: Chapter 8, §9). The same thing happens with painting. Not so much that the least should imply the most—flavourlessness is not understatement, an inversed intensive figure—but because this deceptive approach calls for an unfolding, even an unfolding in the long term (again it is thought concerned with process), which from what is least appealing leads to the feeling of what is inexhaustible.

Consider Gu Kaizhi, the first great painter of China: 'His paintings are like silkworms reeling off their threads in the springtime: at the beginning this appears very flat and easy and, from the perspective of resemblance, there are at times even errors; but, to consider them more subtly, the Six principles of painting are complete—this cannot be described with words' (Yu Jianhua 1996: 476). Or, again as Fang Xun said: 'There are some paintings which, at first sight, are flat and flavourless, but as we consider them over a long period, they radiate spirituality; these are the ones which are of the first order. There are, on the other hand, those which, when the gaze falls on them, seem successful, but if the gaze is cast upon them anew, they are no longer interesting'. Wu Daozi contemplated a painting by Zhang Sengyou thus: 'He considered it twice and on the third occasion set himself down beside it and would not leave it' (1962: 16–17). Whether the painting lends itself to this unfolding while still keeping itself in reserve (in withdrawal) and never stops being 'savoured', instead of astounding by its beauty, but also fixing the sensible, will be exactly what holds it in 'life'.

XXI

THE BEAUTIFUL DEAD

There is 'life' precisely in the sense in which an unfolding to come is implicated. According to the most ancient Chinese dictionary (the *Shuowen*), 'to live' (or 'life': *sheng*, 生) means 'to advance, to progress'; the hexagram depicts vegetation that thrusts from the ground (the horizontal line at the base of the figure) and rises stage by stage. 'To live' or 'life'—if there is a term we expect to find in the same way without fail in every language, as a founding term that is self-evident, an obviate term speaking of what is common to human existence, this really is the one. And yet I am no longer sure of its compact unity: If it lends itself to various approaches, does this not already imply an option? Suppose this too was a matter of *perspective*? In Chinese, the same character is used to

say 'to be born', 'to live', 'to engender' 'to begin', 'to be living', 'to be imminent'. If it is said that a painting is 'living', it therefore means precisely that its figuration gives rise to a surpassing, that it has a future and even that it is only at the start of its advent; that it introduces a process which itself is called upon to be prolonged and even which does not have an end.

'Living', in short, amounts to *being pregnant*, in other words, to be teeming with possibilities for development. Let us remember just the previously cited first principle of painting: 'energy [breath]—resonance: life [to engender]—movement' (*qi yun sheng dong*). This fundamental formula, upon which there has been endless commentary, which just tells us that it can only be understood in an intuitive way; it is to be grasped, we are instructed (Fang Xun 1962: 23), from this thought ('thrust') of vitality, from this capacity to live, which means that the figuration is not stiff and fixed but 'in movement', emanating from the 'resonance' which 'passes through' the painting and makes it thrilling. Chinese thought will not emerge from this; in this respect, it can only repeat itself. In this way, 'to live' means equally, when it comes to painting, a vitality which ceaselessly 'renews itself'—to 'live living'—'without exhausting itself' (Tang Zhiqi); which 'develops profoundly into the distance

and whose outcome is difficult to see' (in Guo Xi 1960: 114). In short, to say that a painting is 'living' is a description as central in China as that, in Europe, of beauty. Could it not even be said that it takes the place of it, being the effect of the concept proper to the beautiful?

By dint of familiarizing oneself with this thought, and even by repeating it endlessly (Chinese thought does not construct itself but elucidates itself), we see these coherences woven together; for want of conceptual assemblages, these affinities are developed. Going together notably with this expression of vitality is the 'spiritual coloration' (*shencai*) of which we are already aware that it dispels the rupture between the visible and its invisible intensification, impregnating the environment, and opening up the figuration to its silent surpassing (*shencai sheng-dong*) (Fang Xun 1962: 56). The fact that there might be a 'vital stimulation' (a way of translating *shengyi*) is also a major qualifier (see, for example, Mi Fu's *Hua Shi* [*Notebooks of a Connoisseur*, 2000])—instead of striking in the instant through shock-rapture, which can go as far as dread, painting generates a dynamic tension, through its figuration, which holds it in its flight and bears it again towards further engendering, prolonging its resonance in intimacy; and whatever one paints, flowers,

trees, people, landscapes, and even rocks are also a compression of energy.

We can of course recall that this is also the case in Europe. We will remember in particular that painting is expressed in Greek as 'drawing of life' (*zôgraphia*, and an actual painting as '*zôgraphème*'). 'The painter's products stand before us,' said Plato, 'as though they were alive' (*Phaedrus*: 275d; in *Cratylus*, Plato even laconically compared the 'living' to 'names', designating paintings in this way). What did Vasari say when he wanted to celebrate the painting which was reborn in Italy by freeing itself from Byzantine influence? That Cimabue 'knew how to give a little more living, natural and mellow character to cloth and clothing and to all things that the Greeks did in their linear and defined style'; or that Giotto 'represents Lord Malatesta with a bearing so alive that we could believe him present'. Indeed, could there be a more fulsome praise, that is, in relation to the *Mona Lisa*? 'Her clear eyes had the brilliance of life'; or 'her nose, with its delightful pink and delicate nostrils, was life itself . . . ' But what did Vasari expect of what he was calling 'life'? It was *resemblance*, that of the velvet of the dress or the complexion or of what he named in relation to the very face of the *Mona Lisa* the 'imitation of nature', therefore not deviating from the

Platonic conception of painting as *mimèsis* and reproduction, to which, as we know, modern painting would be opposed with all of its strength; and not from a conception of painting as a device in tension allowing energy to propagate and from which *resonance* emanates.

By following Shitao, we can understand better how painting can *bring out life* through its configuration and, by doing so, to engage an incentivized (interactive) process declared to be 'inextinguishable'— instead of aiming to reproduce the image from life, the illusion then being such (the well-known 'trick' of the eyes) that one could be deceived by it (Zeuxis' grapes). Above all, we need to be vigilant not to cut the landscape up into 'sections', as the treatises for beginners teach, in a mechanical way by separating 'one level for the earth', 'one level for the vegetation' and 'a third for the mountain' (or a simple variant: the 'staging' at the bottom, the 'mountain' at the top, with 'clouds' between them, if you like—see Shitao 1984: Chapter 10). The result, says Shitao, would be that 'there would no longer be life passing through it'. It is necessary on the contrary for the whole landscape to be 'crossed by the same energy which is transmitted through and through' and which 'links' all the elements: the 'power of the brush' will then be able to

'penetrate a thousand peaks and ten thousand vales', a 'trace' will never have been left in it which would render the line 'vulgar' owing to its rigidity. With this impetus causing everything to communicate, we 'accede to the dimension of the spirit' (*ru shen*). Or, when trees are painted (in groups of threes, fives, nines or tens, it is advisable, as we have seen (ibid.: Chapter 12), that each 'in one sense of another, whether *yin* or *yang*' should reveal 'an appropriate aspect'. In the effects of contrast and tension they generate ('by projection-retreat', 'between high and low') 'life and movement emanate to their limits'— like 'heroes', these are the ones which 'get up and dance, raising and lowering their heads, crouching or planting themselves upright, swaying or balanced'.

One notion is at the heart of this expression of life by a process of internal engendering rather than by imitation of appearance—in every living structure and as early as the elementary state of the cell, *polarity* is that capacity to possess two poles distinguished by their potentialities or their functions (*yin* and *yang*, as the Chinese say) from which life is given birth. This principle, which we know to be at the heart of Chinese thought as well as its conception of painting, is what we will always see being evoked from treatise to treatise, from chapter to chapter, so aptly contained

in Chinese which also expresses itself by polarity (what is all-too-superficially called its parallelism) and not by syntactical construction. We see a polarity at work in the very heart of the landscape, as Shitao evokes it in these successive partnerships, and this is why the forms of landscape are in transformation, born from these continual interactions ('inside-out'/ 'right way round'; 'oblique/in profile'; 'concentrated/ dispersed'; 'near/faraway'; 'internal/external'; 'inter-rupted/prolonged'; 'in process or plundered', and so on): 'such is really the great beginning of life (*shenghuo zhi da duan*—see ibid.: Chapter 5). But also the polar-ity is (already) at work in the handling of the brush: working from its tip or its side, upright or inclined, opening or closing, bounding or gathered up, giving flesh or bone structure, and so on (and in the same way for the ink: pale or dark, dense or sparse, and so on). Ink and brush form together the great polarity from which the painting proceeds: 'At the heart of the ocean of ink, the spirit is firmly established/under the tip of the brush life is cut and springs forth' (ibid.: Chapter 7). But also (already) in the way the wrist is guided: either firmly so as to penetrate into the depths, or causing the brush to fly in a lively way; either accelerating its course so the line gains in strength, or holding it back so pleasing curves will

emerge, and so on (ibid.: Chapter 6). The painting is born (lives) engenders (all of the associated meanings of *sheng* 'living-pregnancy') from these multiple variations in which the one each time calls upon the other and renews itself through it.

Whether it a matter of movement engendering or of engendered figuration, 'empty and full' (*xu-shi*, 虚实) traditionally expresses this functional complementarity of oppositions such that the *empty*, in desaturating and communicating, is what allows the *full* to satisfy its full effect. This partnership is the centre of the Chinese conception of painting. It is sufficient to raise the tip of the paintbrush, leaving some white at the heart of the line, and this line animates as it empties itself (*xu er ling*—ibid.: Chapter 12)— decanting itself of its materiality, it does not get bogged down in its 'trace' and is deployed beyond the tangible. For the invisible (the absolute), not being constituted in terms of 'Being', will be understood as 'undifferentiated stock' or this 'great emptiness' (*wu*, *taixu*) where the demarcations of things are unmade, where sensible concretizations are de-individualized; where forms become evasive and communicate energies. You simply raise the brush, empty the mark, allow a white to appear at the heart of the line, and it will no longer be limited to the visible, as restrictive

and solidifying as it is: of itself it opens out on to that invisible where the 'spiritual' hides and from which comes 'life'.

What then is the difficulty that classical painting in Europe comes up against and even where should its failure be situated? I believe it could be expressed in one word—to *represent* the spiritual leads nowhere. The faces and attitudes in it express most strongly the states of the soul and affective tensions—such as the faces and postures at the foot of the cross (Giovanni Bellini at the Brera)—but the spiritual itself is not represented. How has it normally been done? By recourse to artifice. To depict that other level (of the spiritual or the Invisible) the Virgin is separated by clouds (in all those *Coronations of the Virgin*), haloes surround the heads of saints, or luminous rays symbolize the divinity of Christ. . . . What heartache and repeated vexation for painters, I imagine, to have to do it like this! Or to have to attach plumage to the so-graceful bodies of angels. This is of course only a stop-gap, completely conventional—the separation in principle between the visible and the intelligible allows nothing but this cheap symbolism. The European absolute being conceived metaphysically as from another world, in terms of Being, and therefore in affirmed rupture with the sensible, there is no

image which in its own figurative development (as it makes the choice of 'circumscription' and of the 'distinction' of forms, that's to say of the determination which creates 'being', from whence comes beauty) is able to elevate itself *by transition* to the spiritual, and this in spite of all the predictable efforts of vague distances and *sfumato*.

Such is the problem with which the beautiful is finally confronted—it is resultative and terminal at the heart of the visible; *it does not go deeper* from the visible to the invisible. It integrates, totalizes, harmonizes, but *does not permit a surpassing*. It stops and hence eternalizes, instead of calling upon a development to come—the very one that Chinese painting has promoted as being 'life'. Or, to go beyond the visibly beautiful, it is necessary to slip into the symbolic and to interpret it analogically on a level of ideas but for that to leave the sensible realm (to pass to the intelligibility of the Idea). That is why the beautiful 'dumbfounds', 'terrifies', grasps and ravishes in an instant, but it does not give rise to the sense of savour which 'flattens and fades' and so leads, through a continuous process, to the 'flavour beyond flavour' (*wei wai wei*); or to the 'vague' or the 'thin' (here and there dispersed) that leads to the 'landscape beyond the landscape' (*jing wai jing*). Its distinct forms bring

forth this height of visibility; indeed, by their breaking in at the heart of the non-definition of the visible, they make the absolute flash into sight, but they are not unravelled (they do not widen out) in the invisible. The fact that the beautiful would be without a beyond, that it would be the extreme leaving nothing left to be desired, that it rises like a definitive wall blocking the path to any progress (when it is 'beautiful', every time I imagine nothing more than this painting), is what links the beautiful to death. Adorno has noted it, but the fact that Chinese painting prefers this *living engendering* to the beautiful leads it to more meditation: 'The beautiful speaks not only as a messenger of death, as Walküre does in Wagner's opera, it also assimilates itself to death conceived as a process' (1984: 78).

The beautiful is in retreat (makes a secession) in relation to the movement in continuous development or 'impulse' that is life; it is solemnly enclosed in its realm. Is this what Hegel had already said? In isolating itself from all influence or ordinary dependency, in making its external manifestation correspond exclusively with its concept and internal content, remaining in this way exempt within itself and being consolidated within itself (*mit sich zusammengeschlossen*), the beautiful is death to immediate existence (*abgestorben*

dem unmittelbaren Dasein—Hegel 1986: 207). But the beautiful is also given up to death because, having reached this ultimate and come up against this impassable barrier, it is left with no possibility of intensification other than to sink into the abyss; or, from its limit of Being, to efface itself in non-being. Having been established by means of a breaking open in the heart of the sensible, it thus possesses no other future than its own abolition; or its presence already indicates its inescapable absence, the one appealing to the other. Otherwise, the beautiful is at risk of displaying itself and taking pleasure in its appearance, of allowing itself to be absorbed on the surface and to become *décor*. To escape the pretty, it maintains its intensity only under the pressure of death and in a dramatic way—its time is that of the ephemeral and its condition is fragility. We see it already with the Nude—the unsurpassable beauty of that body is apparent only when confessing its mortality (even when it is gods that are painted). Venice offers another example—'Death in Venice' is not a specific story but the rigorous concept of the beautiful. Another variant: 'See Naples and die.' Because what is there left to see afterwards?

Venice is beautiful only when threatened by its disappearance (with which, in truth, it has always

been threatened by the deprived shore of the lagoon). Otherwise, it would only be a pasteboard theatrical setting. It would be like Bruges, its conscientiously repainted and regilded Flemish rival, where the gaze is not worn out by having too much to see but slips across it without sticking (except when Bruges shakes itself after the rain). But Venice escapes the postcard view because it maintains its enchantment of forms and colours with full force outside the abyss, like a mirage, as the fate of its northern neighbour, the depopulated Torcello, hovers over it—all of this visibility arises with a magical stroke, but it is leprous; humidity eats away the coloration of the facades and the briny sea overwhelms with its eddies the steps of the palaces with every passing *vaporetto*.

XXII

THE CULT OF THE BEAUTIFUL

The smile of the *Mona Lisa* or the city of Venice are already objects of an exclusive homage because they touch the limits of the visible, which they cause to spring forth from what is unsurpassable, like a flickering of the absolute in the face of death. Homage is rendered to them in a mythological way as to those, heroes or demigods, who are entrusted with the burden of leading our fate to its limits. Once the Judgement like that of Paris has been issued, this essence of the beautiful that they are called upon to incarnate at the heart of the sensible world monopolizes attention on them, places them apart on the earth or in museums. Without this sacralizing beautiful in the pantheon into which they have been placed, Venice or the *Mona Lisa* would not know the symbolic and

collectively shared charter of exception, which goes well beyond the circle of travellers and aesthetes, and I am unaware of any functional equivalent in China or in other countries of the Far East to Venice or the *Mona Lisa* being erected as totalitarian symbols of beauty. Even if it is true that these countries, and undoubtedly also all other countries of the world, have in the end borrowed from us these traditional images of the beautiful and we have since made them 'global'—this is fortunate for tourism but also a great disaster.

This beautiful itself, appearing only as vistas into the world, appeals to the same veneration as the divine into which it initiates; as a concept and even as the model of the concept, the one that teaches us to pass from the sensible to the idea, it has now become the object of a cult; and even the sole cult remaining to us in modern societies, since the gods are dead. Plotinus told us about both at the same time. On the one hand, that the Beautiful itself is alien to the world (*ektos tou kosmou*); that the perceptible [*sensible*] beautiful places us on our way but, by taking us to the limit of the perceptible, it does not know what lies beyond; it is therefore necessary for us to break with what is perceptible and look with eyes of the soul 'leaving sense to its own low place'

(*Enneads*: I, 6, 4). Of this beautiful, which is 'beyond the beauty of Evening and Dawn' (ibid.), the perceptible beautiful is only a weak image, a pale reflection and, as such, effectively as fleeting as a shadow. On the other hand, this 'exceptional' beauty is turned towards the spirit, but facing it we remain 'without means' (*kallos amechanon*), which 'dwell[s] as if in consecrated precincts' and even which remains 'apart from common ways where all may see, even the profane' (ibid.: I, 6, 8), that it is necessary to ascend as one does to a temple, divesting one's clothes and purifying oneself, like new converts. In relation to the beautiful, Plotinus takes up again the only language that remains, the non-language language, that of the ineffable used in the ceremonies of the Mysteries. Elevating us in the course of successive purifications not only above the perceptible beautiful, but also of that which exists in the soul, to that of the Intelligible that is offered to the *epopteia* alone, is the 'beautiful beautiful' (*to kalon kalon*), the only sort which 'exists' and which is not soiled, being the 'original' beauty, which is nothing else but 'in itself' and that nothing can contaminate; this is also why a simple reflection of it, as fugitive as it might be, so faded, is in fact be enough to cast us into 'dread' (*thambos*).

Plotinus bequeathed us intact this theology of a hypostasized beautiful which reiterated secularizations, including those of the contemporary age, have never been able to cast off. On the contrary, they have resulted in isolating and promoting the Beautiful as the only divine thing left which does not compromise, but is compatible with, science and even very ably counterbalances it, and into which the religious consequently can flow back without difficulty. They have even confirmed the beautiful in its role—the beautiful is there, like an erratic mass in complete disenchantment with the world, as what remains to us from the time of the gods. It is placed in the museum, the modern temple; it offers the immense, even unique, advantage of a profane sacred. Even common opinion has turned it into its ordinary mythology as is borne witness by everyday exclamations and tourist emotions when *confronted* by the Beautiful—the collective consecration of the Beautiful, which is the counterpart to the democratic experience it represents, is one of the great fabrications Europe has made and that it still consumes, today perhaps more than ever, without even suspecting it.

If the beautiful possesses such credit, it is because it serves as the ultimate stage of the happy life; it is the final messianism left to us, and the great

reconciliatory urge can still be projected on to it, phantasmally but in the open, and no longer having to be rationally disguised. With it, Plotinus furnished a theoretical version (the most presentable) of paradise. In this 'pure' beautiful, the beautiful of the 'World Beyond' where everything is 'transparent', nothing is still shadowy or screened and 'every being is lucid to every other, in breadth and depth' (*Enneads*: V, 8, 4). Because each 'contains all within himself, and at the same time sees all in every other [...] the Sun, there, is all the starts; and every star, again, is all the stars and sun'. The beautiful then responds to that dream in which identity is maintained, but without introducing any further difference; where determination is affirmed, without which there would be neither form nor beauty, but without any exclusion. Places really exist, offering the variety of a landscape, but they no longer dissociate and even in truth are no longer locatable: 'There is no foreign ground upon which each of us advances: wherever we are is precisely where we are; the place from which we have come is still with us when we advance to what is higher . . . ' (ibid.).

What consequently characterizes this Beautiful of the 'World Beyond' is that in the end it abrogates this truth, which we thought was unbreakable,

according to which 'every determination is negation'. Yes, the determinations are maintained, and beauty holds to them, but here the negations which govern them are henceforth erased among themselves— these determinations of the Beautiful are no longer, annulling logic, negatives of what is opposed to them; or, a more political version, the rights of 'each person' are maintained in it, but each person no longer has to submit in order to be integrated into the whole because, as Plotinus tells us, he is himself from that point 'whole'. The beautiful therefore plays the same role, in short, but fully, in affirming and radical-izing itself as 'beautiful', as the undifferentiating void of Chinese 'painting-thought'—all contradic-tions are finally raised in it and all disjunctions dis-solve. But access could be gained to this fundamental void of things at so much less cost in the Chinese version of the spiritual! When raising one's brush, when allowing white to appear, when rendering forms evasive—freeing oneself from the narrowness and rigidity of the sensible, but without having to convert oneself to another reality; in practising transcendence ('a flavour beyond flavour'), but without having to assign another object to it. In the (heroic) theoretical construction of the West, in contrast, the Beautiful, being substituted for God, is obviously this 'great

Object'; and this is why mystical ideas are so conveniently transferred to it.

Such effectively is one of these powerful assimilations which 'Europe' has created—the beauty of God, which is almost absent from the Biblical text, in any case, is never stated as such in the New Testament, became (via Platonism) a major theme of Christianity as it was being formed. What unstoppable ideological pressure was therefore secretly involved, in the convergence between Greek exigencies and the theo-kalic tradition, to the point that Augustine called God, in *Confessions* (1962: III, 6, 10) the 'beauty of all things beautiful'. To convert the God of Terror or Love into the beautiful God has had at least two consequences. First, it has made God the Creator the unique source of all beauty: henceforth, the beauties of the world have their assigned origin in divine intelligence; they are the work of God Himself and are worthy of him. Secondly, for the transcendence of beauty to be improved upon it would logically participate in the sur-eminence of the one God. Thus, instead of the transcendence of the spiritual remaining vague, evasive, emanating 'without end' but 'without destination', as in Chinese painting-thought, it is now effectively ascribed to God—*via* beauty—as to its only possible 'object'. But equally,

instead of it being simply an attribute of the divine, as in Plato and even in Plotinus (and, as such, subordinated to the Good) beauty, now being identified with God himself and consequently given as the absolute term of the desire of God, has already won for the beautiful its autonomy. The effect of this, in contrast, is that the beauties of the world, and above all that of the human body incarnated by His Son, will be celebrated as the 'testimony' of God, revealing him instead of simply reflecting him: the Nude (Christ) floods churches—a council resolution. The end of time can be conceived only as the 'apocalyptic' vision of 'Beauty', the contradiction of the visible and the invisible (tearing apart the beautiful and taking it to its limit) being finally removed: God will finally completely 'reveal' Himself in His *parousia*, the Son and the Father equal but in an 'invisible' way—*invisibiliter videri*.

Admittedly, it is clear that the emerging aesthetic, which (from the eighteenth century) introduced the rupture of our modernity, openly cut with this Plato-to-Plotinus ontology of the beautiful according to which the beautiful would exist in itself, and even 'exists' alone for all eternity, before being apprehended by the artist who tries to impose form on brute matter—it substitutes for it the inventive point of

view of production, each creative genius having to invent the idea of a maximum of beauty; just as it breaks with that Christian eschatology according to which humanity would finally accomplish its vision only through face to face contemplation with the beauty of God. The beautiful is henceforth considered only as a matter of 'taste', referring only to the pleasure now experienced, and the subjective conditions of its reception. For all that, does it abandon any idea of a beautiful that is a stranger to the world and that its distance leads it to consecrate? Let us not forget that the 'ideal' appears precisely in this context in Europe and precisely above all in relation to art (for instance in Diderot's *Salons*): Would it not have been in this respect a question, in this 'ideal of the beautiful', of the vigorous offshoot and candid relay of what was nevertheless believed to have been definitively entrenched? Because the 'ideal' always relates to this (Platonic) status of the Idea of which one is in search and will not be able to possess.

We will therefore not so easily emerge from the cult of the beautiful and what it bears along with it of the reign of Ends. Is the beautiful even really detachable from it? If it wasn't, why did Kant need to add the chapter on the 'ideal of beauty' for us, if it was not to carry forward this supreme model of the

beautiful, not only of the idea-norm of the imagination furnishing its optimal mean, as rule and condition of the beautiful but also of the Idea of reason which makes an appeal to humankind's 'ultimate ends' (teleology again) and of which no sensible representation can be hoped for? (Kant 1978: §17). Or, for Hegel, even though he adopted a modest version of romanticism, there was the 'beautiful ideal', which needed to be detached from the order of nature as well as to be purified from all of the contingency and exteriority characteristic of ordinary existence, and this in order to preserve only what is adequate to its spiritual content, and is called upon, in being released from this limited life, to accede to the 'shadowy and silent land of beauty' (Schiller), which remains the destination (Hegel 1986: 207); in it the beautiful begins to realize the great anticipated Reconciliation, even if it is in a still too immediate way.

The question moreover still comes back to us, in an oblique way, in a different light: Was it not precisely this idealism of the beautiful that amazed the Chinese when they started to discover European philosophy at the end of the nineteenth century? In fact, they had to enter into a second period of translation, after that provoked by the encounter with Buddhism when it came from India, their first

'West' (we Europeans are, as is right, their 'Far-West', *yuanxi*), some fifteen centuries earlier; and that, dominated by Western knowledge, they undertook the great comparison of the 'strong' and 'weak points' of their language and culture. Traditionally so unconcerned with others, they started to think about themselves from the point of view of this outside force which suddenly assailed them. Confronted with Westerners who had developed at once conceptual 'generalization' and the 'specification' of analysis, the Chinese were characterized, they discovered, by their taste for the 'concrete', for 'practice', the 'common' and the 'ordinary' (Wang Guowei 1940a: §14). They noticed that Westerners had developed the autonomy of art while they had remained true to a unitary and social conception of culture, which would explain why many of them then began to feel that 'Chinese philosophy and art was underdeveloped'. Thus, after reading Kant, they began to fashion into their language equivalents of the great European categories: 'art' (*meishu*), the 'object' (*duixiang*), 'form' (*xingshi*), 'judgement' (*panduan*), 'the beautiful in itself' (*mĕi zhi zi shen*); and even the distinction between the 'beautiful' (rendered as 'eminent beautiful', *you mĕi*) and the 'sublime' (*hong zhuang*); or the idea of a 'pleasure' (*ke ai wan*), but which would be 'have no relation with

the profit, or loss, experienced by the self' (a way of rendering the idea of 'disinterested') and of 'absorbing oneself into the contemplation of the form of the object', and so on.

Introspection—what notion could the Chinese place in relation to the conception of the 'beautiful' they discovered in Europe? From the outset, we will be rather surprised to learn that one of the first to introduce European thought into China, and a great reader of Kant, Wang Guowei (1877–1927), proposed that of 'ancient elegance' (*gu ya*, 古雅). A parallel all the more amazing since the respective realm of the two notions do not overlap, as he himself started by noting—the beautiful is concerned at once with nature and art while 'ancient elegance' arises only from aesthetics. Nevertheless, they are joined by the notion of 'form', to which the beautiful is linked, and even 'ancient elegance' would be that 'secondary ' form' which 'manifests the form of the beautiful' (doubtless a way of bypassing the notion of 'representation' which remains the major absence in translation here). But why go looking for what is only one notion among so many others in the old Chinese stock, and one never defined, prevailing only through cultural distinction and of a refinement continuing from the past, in order to raise it up in relation to beauty?

The facts oblige us to acknowledge, the Chinese man of letters who has studied the West tells us, that 'there are works which cannot be considered completely beautiful', but which for all that are not 'utilitarian' and which did not necessarily have 'geniuses' for authors (Wang Guowei 1940b: §15). Starting with which the great oppositions would be sliced apart with an axe (borrowed from Kant): whereas the judgements relating to the beautiful and the sublime 'are a priori universal and necessary', the judgement relating to 'ancient elegance', which varies according to the period, is revealed *a contrario* to be 'a posteriori, empirical, particular and fortuitous'; consequently being inferior to the beautiful, this 'ancient elegance' will be appropriate to those for whom the beautiful and the sublime remain inaccessible and who for want of 'genius' have 'application'. Nevertheless, it would not simply be a stop-gap, this thinker concluded, but would possess a particular merit, which is precisely to remain closer to 'common experience'. An ambiguous but symptomatic way of thus raising a barrier at the same time as it borrows it, under cover of the traditional and very prosaic figure of the Chinese man of letters, from the great myth suddenly being unfurled (in cumbersome way?) of the Beautiful.

What does the word 'common' mean here? Indeed, understanding better, who might 'the education of the greatest number' concern, as it could be acquired through 'personal formation' (*xiuyang*); but also, I believe, for the Chinese literati, who does not assign to himself any other vocation except human culture, does not assume a messianic—dramatic status apart, as the Beautiful does, does not take advantage of a metaphysical function (the great Mediation), or make a claim to the absolute. . . . For even if Europe has hardly ever analysed it and that the revelation has come rather from the meeting with (and reticence of) other cultures, one cannot hide the fact that there is a dramaturgy of the beautiful which, since the time of the Greeks, has associated it with Salvation, which then easily slips into *pathos*. The Beautiful is that which confronts Evil and enters into an alternative with it according to a facile Manichaeism, but which (we are surprised to see) is still not exhausted. 'Evil and beauty constitute the two extremities of the living universe' (François Cheng 2006: 13); as such, at the very opposite end of the scales from each other, they are the two 'mysteries' of the world, the two great 'challenges' that mankind has to confront, and so on— rhetorical commonplaces of the fine sentiments in which the Beautiful is immersed.

That the beautiful alone might 'save the world', according to the constantly repeated formula of Dostoyevsky, that it would be the hoped for redemption, is what justifies cult and sacrifice but also best nourishes the cliché machine: the beautiful plays the role of the great compensation for 'humanity's sufferings', as religion once did; it serves as a substitute for politics in transferring the course towards Liberty apart and beyond. To call in this way upon the Beautiful is not neutral. Thus Schiller tells us (in such a banal way) that: whatever the 'political corruption', the 'fine arts' are the instrument which 'absolved from all positive constraint', are the only thing which leads to this great anticipated reconciliation; this is why the artist, devoted to the beautiful, must 'return, a stranger, to his own century' (Schiller 1967: 55–7). Let us nevertheless recognize this: Has not the idealist flight *by means of* the beautiful tempted us, one day or another? Not only is the isolation of the beautiful contained in the principle of the beautiful, but also the beautiful is complacent towards the platitudes of the worst kinds of humanism, which it is not able to denounce. It is ideologically compromised at the same time that art is (practically) bogged down in it and would renounce its own exigency within it. Thus, to emerge from so much mystification and

powerlessness (and grandiloquence) will be the pledge that was given to our modernity.

XXIII

TO BE FREE OF BEAUTY?

However, to emerge from the hegemony of the beautiful requires nothing less than a frank critique of classical Reason on which the beautiful depends in conjoined ways. These three sides form a triangle on the tripod of which the beautiful is perched—the 'pedestal' of the beautiful, as I have called it. This requires above all a critique of *representation*, the trial of which began with Hegel reproaching it with failing to grasp infinite determination—one could also pursue it starting with what we learn from its non-arrival and therefore also its non-necessity in Chinese thought: representation is suspected not simply of artificiality because of its too advantageously abstract, isolating and substitutive character; but it will be equally necessary to denounce the mastery-distance

(security consciousness) it believes it is able to maintain in relation to what, in its springing up, does not allow itself to be so conveniently arranged in this present of a simple 'placed before' (to this overly well-governed before of the *Vorstellung* will already be preferred the more immediate and less framed exposure of this 'there', *da*—the *Da* of *Dasein*, of the *Darstellung*, already in Kant and Hegel). In other words, this is a way of going back prior to the split which knowledge operated for its own needs between the 'subject' and the 'object' and with which the reign of representation is associated. It also means a rupture with *judgement*, which demands the largely illusory figure of a sovereign Subject completely and instantaneously present to itself. From the mouth of a painter friend (when I went to see his pictures) and which could be equally true for Chinese painting: 'Let it infuse!', an immediate word of warning indicating that to judge something as 'beautiful' (or not) would now be meaningless—what is needed is a process of engagement with the work (besides, am I just 'looking' at it?) the effect of which lies in the long term, working somewhere unknown to me and the result of which perhaps even escapes me. This is finally a refusal of *satisfaction*—instead of the too-facile apprehension of taste founded on 'pleasure', we

prefer the virtues of an *experimentation* which would not conceal itself as a simple condition but becomes the declared end of the work. For if satisfaction is lacking, it is not so much because there the public have been slow to appreciate the innovation of the artist (the 'in fifty years!' of Stendhal), but because from that point on one distrusts (a commonplace also turning into conformism) this adhesion going to the point of alienation and which will cover over the critical work engaged in by art. Modern art nevertheless bangs its head against this declared refusal of all complacency, because to what point can it abandon the idea of producing satisfaction? Or what other, complex and even contradictory, 'satisfaction' could art still aim at, being understood that it is no longer this 'pleasure' before the beautiful?

Let us take one more step back in these conditions of the beautiful. The renunciation of the beautiful, from the point of view of production, touches the basis upon which the beautiful sits and has for so long been enthroned—*form*. Could any 'beautiful' exist without 'form'? Would not the abandonment of elaborated form signal at the same time the forsaking of the beautiful? At least, if it is no longer understood as a figure, a *Gestalt*, but also, more essentially, in the Kantian sense of the unification of the diverse

through the imagination according for that purpose with understanding—an accord that is consequently too finalist. It is henceforth the *process* which replaces this final-formal. The consequences are that the beautiful, forced out of art, today refers to design which aims without any hang-ups at satisfaction, even interested satisfaction (the very existence of the object is no longer indifferent for me since I live with it, turning it into my setting and everyday use), and openly respects form. Thus art, finally uncoupled from the beautiful (an end of the 'fine arts'), and remaining henceforth the only pertinent term, withdraws into its own territory in which everything again becomes possible. I no longer cultivate the beautiful but I am an 'artist'. Art today is no longer realist, but nominalist, in the sense that it no longer exists except according to the concept which recognizes it (Duchamp, with his urinal, undoes the beautiful but confirms this *nominal* concept of art). Moreover, through this step taken by the process into form, the emphasis is no longer placed on the completed piece but on the *work* itself. The form is the finished, the polished, the dead, and this is why it is condemned by itself. Thus to return to an earlier stage would not be so much to valorize the draft as to affirm that what is important, and even as such is sufficient to itself, is the construction

site—this state (not to be gone beyond) in which non-integrated tensions subsist, where incoherences are exposed and where the beautiful has not yet committed havoc by burying the turbulence of life beneath harmony.

From a historical and notional point of view, there have been at least three periods and three terms which have punctuated this breaking up and letting go of the beautiful. A jubilant execution as much as a liberation, moreover, as happens each time a sovereignty which was believed to be untouchable is dethroned, but whose execution is equally necessary so that the Rupture forming modernity can be given self-legitimation. First (in the eighteenth century), the beautiful was split in two and the *sublime* was detached from it. This only involved a reduction of its pertinence and a putting of the two in concurrence. For the sublime, as it overflowed the beautiful, revealed that it no longer resides in the presented object, which is now nothing more than a support and opportunity, but that everything that happened henceforth concerning it was in the sole reaction and realization of the subject. Consequently, instead of being a mater of form, the sublime proceeded from the unformed; or again, in Kantian terms, instead of trans-mitting the idea of a natural finality, it gave rise rather

to that of a chaos in nature; instead of producing a harmonious state (between imagination and understanding), it provoked rather a state of violence among the faculties (imagination and reason); and the satisfaction it provoked in consequence was also negative, formed, as we know, from both pain and pleasure, inhibition and effusion, repulsion and attraction.

Then followed the *ugly* (consecrated by romanticism). In it one finds that the raw but also the deformed and dissonant are not only necessary to emphasize the beautiful or even to enter into a dialectical relation with it, but that this ugly quite properly made tension prevail over equilibrium, the dynamic over the harmonic or shock, violence and resistance over reconciliation. In short, it is the ugly alone that cannot be suspected of complacency and affectation. It alone can boast of escaping codifications and submissions, and it even defies them—the ugly, chosen, shatters established criteria. Its virtue as rebellion authenticates it; it makes of it the hidden energy in relation to which the beautiful can only appear reactive and resultative. Not only was the beautiful awakened from somnolence but, through this reversal of values, it now appears only as the secondary, pellicular, negative of this more productive great Negative in whose shadow it has so ingeniously prospered.

The ugly, through its rejection of conformity and sobriety and through the obscure forces it coarsely allows to appear, was already associated with spiritualization. Its demonism was dynamic; lying in secret within it, the *spiritual* ultimately came out of its surge as it measured itself against the beautiful (whether this was through Hegel or Kandinsky). For the spiritual is differentiated from the beautiful so much better than from the terrestrial and the material, its ordinary, or rather appointed, opponents, which meant that it was suspected of idealism. The beautiful revealed this through incompatibility—a Nude is beautiful and can only be beautiful; it will never be 'spiritual' (in step with the preceding arguments: form, the extreme of visibility, the 'whole is there' of presence, and so on). In order for the spiritual to be expressed, the body needed to be clothed, in other words, that a withdrawal had to be arranged, an intimacy preserved, in order for the hidden to subsist and intentionality to emerge from it. The Nude is anti-spiritual, because the spiritual calls for the triumph of the infinite over the finite, of the surpassing over limitation and circumscription of form, the development of the route taken over the instant of terror-pleasure, and so on. The test is simple—it is enough to deform the form to which beauty holds just a little, by stretching it for example,

in order to gain access to the spiritual (from El Greco to Cézanne or Giacometti). As for China, and no doubt this is where the two traditions come together or at least gesture to each other, it is so much better instructed in the deployment of the spiritual owing to the fact that it has hardly paused at the beautiful.

In this putting to death of the beautiful, it is art which has triumphed and affirmed itself—which was already apparent in Hegel notwithstanding the 'beautiful ideal': freed from the tutelage of the ideal, without any further imposed finality, art can henceforth try anything it likes and everything effectively would become possible. Or perhaps it is precisely in this 'everything possible' that it undoes itself in its turn, carried off into the death of that from which it has triumphed. For it is clear that, cutting with the beautiful, art at the same time shattered its great coupling with nature. It loftily sought it, but how is this fracture to be repaired? If, since the time of the Greeks, the one has been conceived in opposition to the other, forming an alternative (natural development on the one hand or human craft on the other—*phusis/techné*), the one is also conceived only on the model of the other. Art, as we know, 'imitates nature', but nature being equally conceived in the image of the artisan (Aristotle is the theoretician of this)—it wants,

anticipates, gives itself ends (seen again in Kant). Belonging to one as to the other realm, the beautiful formed a bridge between them. The surface rivalry (must art by limited to 'beautiful nature'?) rested on a tacit understanding whose element of reassurance is still difficult, I believe, to measure, and how this dissociation of art from nature, impelling the experience of its autonomy to the point of exhaustion, which also entails the abandonment of the beautiful, effectively rejected human craft, which no longer had a handrail to hold on to, in an exceptional adventure whose fascinating and vertiginous character, is equalled only by the solitude it confronted.

Chinese tradition offers as a point of useful comparison in relation to this point because, not having opposed art to nature, it has not conceived of any distinction between them. Is there even, strictly speaking, a notion of 'nature' in China, since everything there speaks of nature? The 'Sky' expresses nature in it as a regulated renewal of the world and a *Fond sans fond* (bottomless Stock) of the process of things. 'Heaven and Earth' are also coupled and form the great polarity, but so is the spontaneous arrival (*ziran*: 'of oneself accordingly') as well as the 'way', *tao*, and so on. Thus, while artistic processes have enjoyed such expansion in China, a proper notion of Art, in opposition, has

barely developed (the character *yi*, 艺, appeared only incidentally in the work of Fang Xun in the eighteenth century); it, too, was borrowed from Western categorizations, at the end of the nineteenth century. For what was said about Chinese painting? That it 'participates' in the great process of 'creation-transformation' of things (*can yu zaohua*), in other words, that the process of painting, does not 'imitate' (so as to make this its object) but is of the same order as everything happening in the world. This is why, as we already know, the 'image' of it is at the same time a 'phenomenon' (the same term is used—*xiang*, 象), the internal play of polarities causing the one as much as the other to *live*, and that, among them, a theory of representation cannot be found to have developed. There has therefore been no need to isolate and promote the 'beautiful' in order to keep them united.

TO RESTORE TO BEAUTY ITS STRANGENESS

Such a decentring of perspectives, *by way of* China, appears to me salutary, not in order to look elsewhere for a solution—an *elsewhere* can never furnish anything other than a utopian solution—but because it can provide a starting point from which to unmake the contradiction that, in our days, otherwise closes in on us in like a vice. It may be impossible to continue to believe in the beautiful—the last cult to be abolished—but neither can we do without it. For if one sticks to this internal history alone, that of the beautiful banished by art after having ruled so sovereignly over it, but threatening also to drag art down in its fall, the situation then turns out to be blocked. And already (still) from a theoretical perspective, as Adorno said, 'The beautiful cannot be

defined, but neither can the concept of the beautiful be dispensed with altogether; it is precisely what we call an anti-nomy' (1984: 75–6, translation modified). We still find ourselves no further advanced, in this respect, than at the end of *Greater Hippias*. For, continues Adorno, 'If people did not make statements about this or that artefact being beautiful in some manner or other, then all the interest in such an artefact would be unintelligible' (1984: 75). What reason would we still have, were it not the beautiful, to claim to hoist up our existence above the sole domain of practical, irremediably prosaic, ends? The aesthetic itself would merely be 'able to describe in historical and relativistic fashion what passed for beauty in different societies or different styles' (ibid.: 76).

Adorno saw an 'antinomy' (on the logical level) in this because he still considered the beautiful to be a category which can be rediscovered as of right in one culture as in another; insofar as he believed, as he said, in the 'fatal universality of the concept of the beautiful'. Obviously, if such universality of the beautiful weighs over us from the outset, then yes, certainly it is today 'fatal'. But if we restore the beautiful to its culturally inventive character? This does not for all that mean to relativize it, because to do so would still be to maintain oneself at lesser expense under its

dependency, but to pose what is here as well the only truly radical question—that of the condition of possibility of the 'beautiful'. Indeed, if we were to the measure the choices which, in Europe, have borne the beautiful and which have led to its hegemony then to its fall, which has, moreover, no longer needed to be either made good or compensated for, would one not have more to hold on to in order to extricate oneself from what has thus become a rut (the 'beautiful ideal') for want of having understood everything that it implies? Suppose, therefore, that we were finally to restore to the beautiful its *strangeness*?

To learn to emerge from the facile universalism without for all tipping over into relativism (that of culturalism) which, since it is only its opposite, categorically changes nothing but keeps us within its shadow and consolation, really appears to me the task to come. In this way, to realize that the beautiful as a category of thought should not be taken for granted but that it results from the possibility that a language has developed more particularly (or a 'family' of language: 'the beautiful' is derived from 'beautiful'); to the conceptual structuration that philosophy has promised locally in linking its destiny to the inquisition of science and to the function of mediation and reconciliation that the dualist prejudice and its

dramatic separation with the world has rendered necessary; as well as to the privilege accorded to determinant form, in the parts-whole relation, to the one and the distinct, to the composition more than to correlation and so on—all of these are European choices. The 'beautiful' names this point of conjunction-contradiction of Being and appearance, of transcendence and the immediacy of sensation, which makes it the sore spot of European thought. It is an absolute captured in the net of the visible, as metaphysics endlessly tells us, which maintains its (unique) force of enigma and fascination. But was it not 'Greek' to cultivate 'enigma'? In discovering that against this China has deliberated on 'mountains and water' deployed only in accordance with the play of their polarities, or that painting or literature could be appreciated there and classified on the basis of a range of descriptions which also respond correlatively, without any concealing and monopolizing of them, or using them as a keystone and finality (perhaps even the *telos*), we will at the same time bring the beautiful out from the false conceptual evidence into which it has been fixed and which will finally rebound on it and throw us into just a little confusion.

A remarkable instrumentality was born from the concept of the beautiful at the same time that it

constructed its own aporia—and this ever since its beginnings on a theoretical level (the indefinable beautiful). In the contemporary world, this is just as much so on a practical level (the level of the tortured 'what to do?' of art)—we can no longer believe in it nor can we do without it. The 'beautiful' is convenient, admittedly, but to the point that its very operativity has made us lazy, or at least forgetful. I am amazed only that no one now has had any interest in undertaking a genealogical investigation into it as Nietzsche did in relation to the good—not into the different criteria or conceptions of the beautiful, which they already admit, but on what has served as a base for the prominence, or even protuberance, of this concept. In other words, in short, I am amazed that a biologist (Jean-Pierre Changeaux 2008) can still today do exactly as was done twenty-five centuries ago—state that the beautiful cannot be defined and, after having once again done its rounds across the perimeter of our notions (of *mimèsis*, perception or representation, and so on), to set up tests of cerebral activation which the very young field of 'neuro-aesthetics' engaged in under the label of nothing more than the 'beautiful', as though a certain and even indubitable support could be found in it. Indeed, as though there really existed the 'beautiful in itself'—evidence of unshakeable Platonism

I no more want to bring into question the whole conceptual value of the beautiful (it is enough to recognize its limited pertinence and presuppositions) than to give in to its commonplace development as a label. If the beautiful itself is no longer considered to be an original, inventive and daring idea the world of the future will certainly be boring. This is a danger so much greater in that it is insidious and that paradoxically, even though art today distrusts the beautiful, this 'category' of the beautiful (theoretical globalization emanating from the West) has in the end been spread over the whole planet. Is there still anywhere in the world that has not learnt to express 'the beautiful'? Or to have to judge it predicatively by saying 'how beautiful'? The irony of history is that, at the precise moment when it begins to implode, the category of the beautiful has ended up imposing itself uniformly. I have already indicated at the start how the Chinese and the Japanese now use it just like Europeans, without any further questioning of its subject, and they readily organize their 'aesthetic' experience within it, this latter term itself being translated as the 'study of the beautiful'. Where does this lead? They then still want (in fair exchange) to demonstrate what the originality of their own 'aesthetic' tradition is. Indeed, they have shown some reticence at the idea that foreigners, not having grown up and lived

in their cultural atmosphere, could gain access to it. I would ask: Is this suspicion with respect to their capacity to be able to communicate their own conceptions in this realm not the consequence, on their part, of the fact that they have borrowed this term of the beautiful, one that has become monopolizing, without criticizing and even analysing it? After naively having trusted it, they now excessively distrust it. Thus this separates them from their own past instead of making it more readable for them; rather than favouring exchange between cultures, it relegates their artistic practice into the ineffable and raises a screen against its being shared.

In Europe, we have for such a long time flattered the beautiful because (a reason which, on the whole, is particular to us), no other cult remained possible for us after the death of the gods. Then the death of the beautiful was announced. But today has the effect of this cry of revolt not itself already been exhausted? What can be done with a beautiful which has been overthrown but is irreplaceable? The fact that we have broken into pieces this category of the beautiful, rebelled against its academic tyranny and what it has sterilized, does not for all that mean that we have emerged from out of the presuppositions which have carried it along. It is time, rather, to update and think

about what is implicit that has privileged the beautiful; to probe at once their prejudices and their fecundities; to measure which paths the beautiful has opened and which it has closed down. In short, to reflect upon what an adventurous idea it has been; and in order to make a start, the beautiful needs to be restored to its *place*. Otherwise there is the risk, as we no longer experience the intrinsic necessity of the beautiful, that we turn it into just a label no longer containing anything conceptual, but which will henceforth circulate everywhere in the world like currency (the zero degree of exchange) and render the gaze so lazy.

A Nude is 'beautiful'; it can be only beautiful and it requires one to think the beautiful in order to think it, and one needs to be *amazed* by the beautiful in order to look at it. Of Venice, for instance, I could only say 'How beautiful'. I could not escape this summons of having to say this on the spot, even if only to myself, of always repeating it, always amazed. I must be struck with 'dread' and captivated by it. Even if one knows all of the sights and they have become banal, the beautiful is the concept of it that is as rigorous as it is indispensable. Admittedly, there are constructions in Venice, even when we go down the Grand Canal, which are in themselves like nasty suburban

dwellings, dirty and without the slightest decoration, and which would be from any point of view sinister, already in prey to death. Or others, beside them, whose indentations on their façades would otherwise be ridiculous. But Venice 'saves' them in fact by composing them into a variety of elements and lights which also places them, as they spring forth before our gaze, at the limit of visibility.

NOTES

1 'Idleness is a beautiful thing.' [Trans].

2 As evidence, among so many other examples in China, the collective work edited by Zhao Laixiang (1992) and in Japanese the collective volume edited by Bito and Akiyama (1984).

3 See, in particular, what is nevertheless an excellent translation into French of Mi Fu (1964: 29, 32, 49, 61, 76, 119 and so on)

4 I would like to thank Marie Farge of the École Normale Supérieure for this information.

BIBLIOGRAPHY

ADORNO, Theodor W. 1984. *Aesthetic Theory* (Gretel Adorno and Rolf Tiedemannand eds; C. Lenhardt trans.). London: Routledge & Kegan Paul.

ANAXAGORAS OF CLAZOMENAE. 2000. *Fragments* (Robin Waterfield ed. and trans.) in *The First Philosophers: The Pre-Socratics and the Sophists*. Oxford: Oxford University Press.

ARISTOTLE. 1984. *Metaphysics* in *Complete Works of Aristotle* (Jonathan Barnes ed. and trans.). Princeton, NJ: Princeton University Press.

AUGUSTINE. 1962. *My Confessions* (E. B. Pusey trans.). London: Dent, Everyman Library.

———. 1977. *De immortalitate animae* (C. W. Wolfskeel trans. and comment.). Amsterdam: B. R. Grüner.

———. 1991. *On Genesis against the Manichees; and On the Literal Interpretation of Genesis: an Unfinished Book* (Roland J. Teske trans.). Washington, DC: Catholic University of America Press.

———. 1998. *The City of God Against the Pagans* (R. W. Dyson ed. and trans.). Cambridge: Cambridge University Press.

BAUDELAIRE, Charles. 1993. 'Beauty' in *The Flowers of Evil* (James McGowan trans.). New York: Oxford University Press, p. 39.

BITO, Masahide and Akiyama Ken (eds). 1984. *Koza Nihon Shiso, Volume 5*: *Bi* (A Course in Japanese Thought: Beauty). Tokyo: Tokyo Daigaku Shuppan Kai.

CHANGEAUX, Jean-Pierre. 2008. *Du vrai, du beau, du bien*: *Une nouvelle approche neuronale*. Paris: Odile Jacob.

CHENG, François. 2006. *Cinq meditations sur la beauté*. Paris: Albin Michel.

CONFUCIUS. 1993. *The Analects* (Raymond Dawson trans.). Oxford: Oxford University Press.

CHUANG TZE. 1992. In *The Essential Tao* (Thomas Cleary ed. and trans.). New Jersey: Castle Books.

CICERO. 1933. *De natura deorum* (H. Rackham trans.). London: William Heinemann, Loeb Classical Library.

DELAHAYE, Hubert. 1981. *Les Premieres peintures de paysage en Chine: aspects religieux*. Paris: Ecole française d'Extreme-Orient.

DIDEROT, Denis. 1951. *Traité de beau* in *Œuvres*. Paris: Gallimard, Ed de la Pléiade.

DOUGLAS, Alfred. 1971. *The Oracle of Change: How to Consult the I Ching*. Harmondsworth: Penguin Books.

FANG XUN (ed.). 1962. *Shanjing hualun*. Peking: Meishu Chubanshe.

FAN WENLAN (ed.). 1978. *Wenxin diaolong*. Beijing: Renmin wenxue.

GUO RUOXU. 1964. *Tuhua jianwen zhi* (Yu Jianhua annot.). Shanghai: Shanghai renmin meishu chubanshe.

———. 1985. *Early Chinese Texts on Painting* (Susan Bush and Hsioyen Shih trans). Cambridge, MA: Harvard University Press.

———. 1994. *Notes sur ce que j'ai vu et entendu en peinture* (Yolande Escande trans.). Paris: La lettrre volé.

GUO XI. 1960. *Linquan gaozhi, Hualan congkan* (Yu Anlan ed.). Beijing: Ren min mei shu chu ban she.

HEGEL, Georg Wilhelm Friedrich. 1975. *Aesthetics. Lectures on Fine Art* (T. M. Knox trans.), 2 VOLS. Oxford: Clarendon Press.

———. 1986. *Vorlesungen über die ästhetik*. Frankfurt: Suhrkamp.

HUTCHESON, Francis. 1738. *An Inquiry into the Original of our Ideas of Beauty and Virtue: in Two Treatises. I. Concerning Beauty, Order, Harmony, Design; II. Concerning Moral Good and Evil*. London.

I CHING, OR BOOK OF CHANGES. 1968. The Richard Wilhelm translation rendered into English by Cary F. Baynes. London: Routledge & Kegan Paul.

JING HUO. 1960. *Bifaji, Hualan congkan* (Yu Anlan ed.). Beijing: Ren min mei shu chu ban she.

JULLIEN, François. 2000. *De l'essence ou du nu*. Paris: Édition du Seuil; reissued in 2005 as *Le Nu impossible*.

———. 2006. *Si parler va sans dire. Du logos et autres resources*. Paris: Édition du Seuil.

———. 2008. *De l'universel, de l'uniforme, du commune et du dialogue entre les cultures*. Paris: Fayard. Avaiable in English as *The Universal, the Uniform and the Common: Dialogue between Cultures*. Oxford: Polity Press, 2014.

KANT, Immanuel. 1978. *The Critique of Judgement* (James Creed Meredith trans.). Oxford: Clarendon Press.

LAO-TZU. 1992. *Te-Tao Ching: A New Translation Based on the Recently Discovered Ma-wang-tui Texts* (Robert G. Henricks trans.). New York: Ballantine Books.

LIU I-CH'ING. 1976. *Shih-shuo Hsin-yü: A New Account of Tales of the World, with Commentary by Liu Chün* (Richard B. Mather trans., annot. and introd.). Minneapolis: University of Minnesota Press.

———. 2002. *Shih-shuo Hsin-yu* (Richard B. Mather trans.). Ann Arbor, MI: University of Michigan Press.

LI WANCAI. 1996. *Shitao*. Shanghai: Jilin Fine Arts Publishing House.

MAI-MAI SZE (ed. and trans.). 1956. *The Tao of Painting, a Study of the Ritual Disposition of Chinese Painting with a Translation of the Seventeenth Century Chieh Tzu Yuan Hua Chuan or Mustard Seed Garden Manual of Painting, 1679–1701*, 2 VOLS. New York: Pantheon Books.

MI FU. 1964. *Le Houa-Che de Mi Fou (1051–1107) ou Le Carnet d'un connaisseur à l'époque des Song du Nord* (Nicole Vandier-Nicolas trans.). Paris: PUF.

———. 2000. *Hua Shi, Songren hualun*. Changha: Hunan meishu chubanshe.

PLATO. 1961a. *Theaetetus* (F. M. Crawford trans.) in *The Collected Dialogues of Plato* (Edith Hamilton and Huntington Cairns eds). Princeton, NJ: Princeton University Press.

——. 1961b. *Phaedrus* (R. Hackforth trans.) in *The Collected Dialogues of Plato*. Princeton, NJ: Princeton University Press.

——. 1961c. *The Republic* (Paul Shorey trans.) in *The Collected Dialogues of Plato*. Princeton, NJ: Princeton University Press.

——. 1961d. *Greater Hippias* (Benjamin Jowett trans.) in *The Collected Dialogues of Plato*. Princeton, NJ: Princeton University Press.

——. 1961e. *Symposium* (Michael Joyce trans.) in *The Collected Dialogues of Plato*. Princeton, NJ: Princeton University Press.

——. 1961f. *Critias* (A. E. Taylor trans.) in *The Collected Dialogues of Plato*. Princeton, NJ: Princeton University Press.

——. 1961g. *Cratylus* (A. E. Taylor trans.) in *The Collected Dialogues of Plato*. Princeton, NJ: Princeton University Press.

——. 1961h. *Phaedo* (Hugh Tredernich trans.) in *The Collected Dialogues of Plato*. Princeton, NJ: Princeton University Press.

PLOTINUS. 1992. *The Enneads* (Stephen McKenna trans.). New York: Larsen Publications.

SCHILLER, Friedrich. 1967. *Letters on the Aesthetic Education of Man: Literary and Philosophical Essays* (Charles William Eliot trans.). New York: P. F. Collier & Son.

——. 1981. *Über die ästhetische Erziehung des Menschen in einer Reihe von Briefen*. Munich: Hanser.